AMISH QUILTS

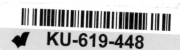

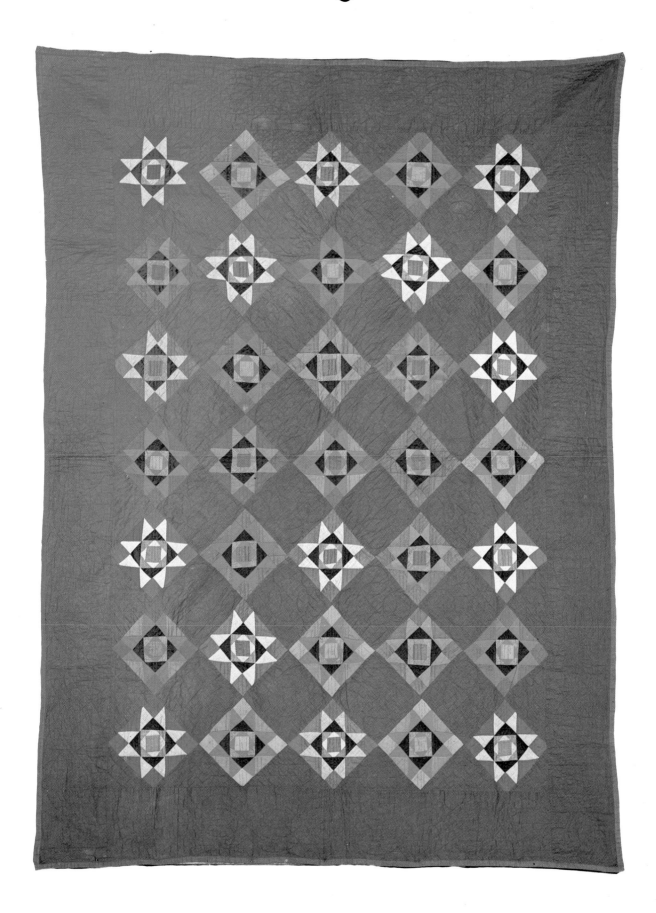

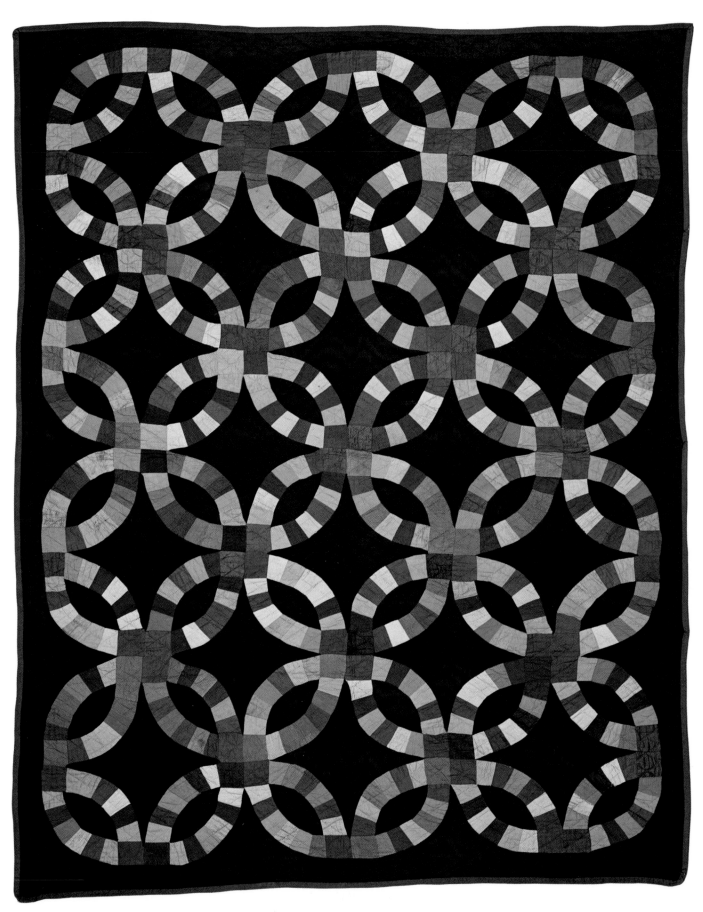

2 (above). Double Wedding Ring, Atlantic, Pennsylvania, c. 1920. 85″ x 66½″. Cotton. The glowing patches winding around this quilt make it resemble a stained-glass window. The red patches have been scattered throughout the quilt to keep the eye moving. (Thos. K. Woodard: American Antiques & Quilts)

AMISH QUILTS

ROBERT BISHOP
AND ELIZABETH SAFANDA

LAURENCE KING

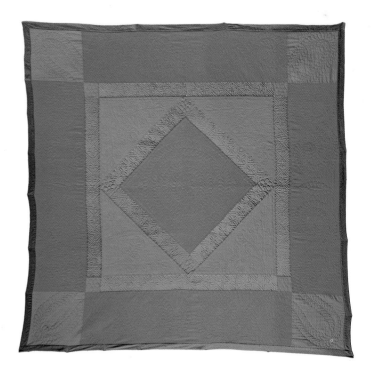

Page 1: Variable Star, Ohio, c.l900. 88″ x 64″, Cotton. The design of this quilt is also called Ohio Star. This rendition is almost equivalent to an 'album quilt' of Variable Stars in its arrangement of numerous colour combinations. (America Hurrah Antiques, New York City.)

Above left: Bars, Lancaster County, Pennysylvania, 1920-1930. 78″ x 78″. Wool. There are tiny flowers quilted in the greyish-green henrietta-cloth borders. The stylized tulips stitched in the corner squares do not appear in Amish quilts before 1920. (George F. Schoellkopf Gallery.)

Above right: Centre Diamond, Lancaster County, Pennsylvania, c.1938. 81″ x 81½″. Wool and cotton. Lydia Lapp of Leola, Pennsylvania, made many bright quilts like this one in the 1930s, using 'hot' tones of pink, magenta and turquoise. (Art Advice Associates and Asher Edelman.)

Opposite: Tumbling Blocks, Ohio, c.1920. 71″ x 86″. Cotton. The blocks in this quilt are skilfully coloured so that they appear three dimensional. The powerful graphic effect is heightened by a sophisticated combination of colours: the double inside border repeats the colours of the overall design. (Bryce and Donna Harnilton.)

First published in 1976 in the United States by E. P. Dutton & Co. Inc., New York.
This edition published 1991 by Laurence King.

British Library Cataloguing in Publication Data
Bishop, Robert
 Amish quilts
 1. United States. Quilting
 I. Title II. Safanda, Elizabeth
 746.46

 ISBN 1-85669-012-1

For a complete catalogue, please write to:
Laurence King Ltd.
71 Great Russell Street
London WClB 3BN

CONTENTS

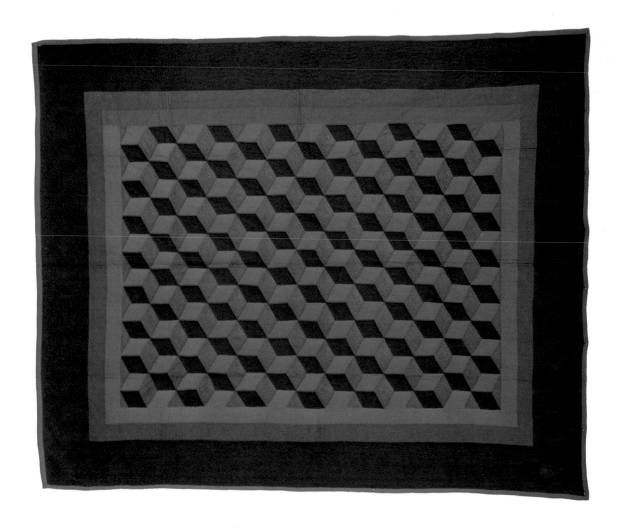

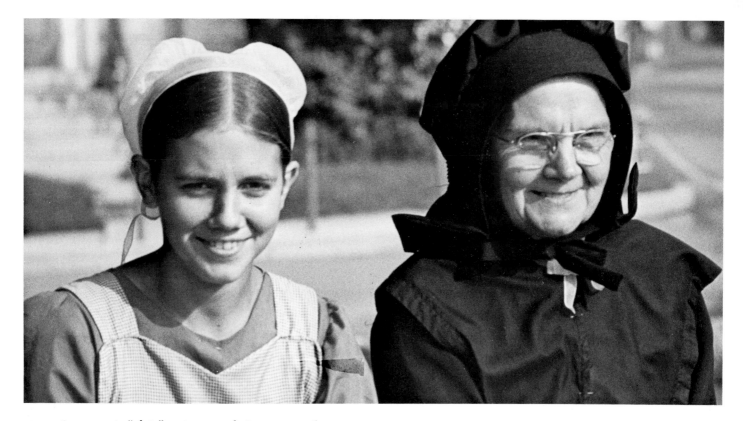

6. Amish women in "plain" costume on their way to market.

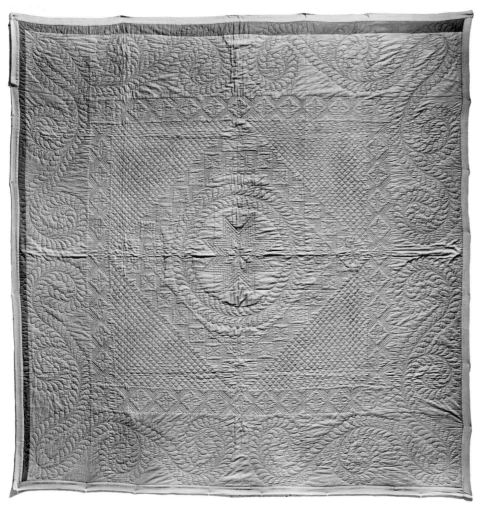

7. Many of the typical quilting designs used by the Amish are shown in this photograph, which is the back of the Center Diamond quilt seen in figure 30. Skilled Amish seamstresses often "put in" twenty stitches per inch.

INTRODUCTION

I. THE APPEAL OF AMISH QUILTS

Farm sales and auctions in the heart of "Dutch"[1] country —whether in New Holland, Pennsylvania; Shipshewana, Indiana; or Tuscarawas, Ohio—are important social events. They attract crowds of local farmers, curious tourists, and antiques dealers eager for a bargain or simply a good time. The trim black buggies and sleek horses lined up near the station wagons and campers indicate that these sales are popular with the Amish people too: they are seasoned auction-goers, ever alert for a harness, some sturdy secondhand furniture, or perhaps a set of brilliantly colored glassware.

In the last ten years or so, the crowds at some sales have also been offered an unusual type of quilt. Stretched across the clothesline or piled with others in a corner, these quilts are unique because of their glowing patches, contrasting bindings, and small-patterned fabric backings. If a browser comes across a pile of these quilts, hastily stacked for sale, he may be surprised by the ripple of colored borders, a brilliant spectrum including magenta and mauve, navy, peacock, a deep green, or a rich brown. These colors are echoed in the dresses and aprons and shirts of the Amish people, usually framed by a black cape or jacket.

When these pieced quilts are displayed for sale, the crowd is impressed by their simple yet powerful geometric designs, and by the juxtaposition of intense solid colors. In one quilt, a glowing green diamond may be centered in a dull gray field with deep burgundy borders, which are framed with a dark blue binding. In another quilt, strips of magenta cotton may alternate with a rich forest green. A close observer will notice that these deceptively simple, pieced bedcovers are hand-quilted with elaborate motifs—roses and tulips, wreaths, feathers, stars, diamonds, and "fish scale," all executed with tiny precise stitches. These striking bedcovers are the Amish quilts so prized today by collectors.

The Amish quilt appears to be a radical departure from the tradition of Pennsylvania Dutch quilts, with their gay and colorful appliqués in warm reds, yellows, and greens, and with their abundant patches of sprigged and patterned calico, all contrived to "make the rash gazer wipe his eye."[2] The Amish palette, especially in Pennsylvania, is glowing but more subtle, leaning toward the cooler tones of blue and green and purple and mauve and earth-tone browns.

These old Amish quilts have a dual appeal—their visual impact and their superior craftsmanship. Some students of modern art are drawn to them because their abstract geometric designs are strikingly parallel to the contemporary paintings of Josef Albers, Victor Vasarely, and Kenneth Noland. These students relish the dynamics of tension and release that Amish seamstresses have produced in their quilts through the skillful manipulation of blocks of color. Other collectors treasure Amish quilts for their intricate, refined handiwork, their minute stitches.

The strong appeal of Amish quilts is at once more complex and more fundamental than an obvious similarity to modern abstract paintings. What is amazing, and worth exploring, is how the Amish woman, with a limited range of materials and with limited exposure to the technical expertise, tastes, and patterns of the "outside" world, has created enduring works of art that are visually exciting and sophisticated. She is not an "innocent" artist in the narrow sense, for she participates in the Amish tradition of fine quilting perpetuated by her family and her community. She does not truly work in isolation, spontaneously crafting these brilliant quilts, but "outside" influences have been minimal.

Amish quilts perpetuate a design tradition that may be unique to this country: a utilitarian spareness and simplicity of style in functional objects. John Kouwenhoven suggests, in *Made in America*, that Shaker crafts have attracted much interest because Americans "recognized the vitality and strength of vernacular forms [which] evolved without any references to the cultivated tradition."[3] The same statement may be made about Amish quilts: they are not derivative, they were developed in this country to satisfy a practical need, and their beauty originates in their successful adaptation of form to function. These quilts, like late nineteenth-century American plows and hand tools and rifles, are refined and elegant, with no unnecessary parts, no frills, no excess appliqués. Because the basic concept of the quilt was simple, the Amish seamstress could focus her energies on color selection and juxtaposition and on the motifs stitched on the pieced geometric shapes. She was not preoccupied with complicated appliqués or stuffing and cording procedures. It is not until the 1940s that some Amish quilts, especially those created for the tourist trade, lose their design strength with the introduction of detailed patches, fussier embroidery stitches, and harsh colors.

Horatio Greenough, author of *The Travels, Observations, and Experiences of a Yankee Stonecutter*, discusses design aesthetics in these terms: "The redundant must be pared down, the superfluous dropped, the necessary itself reduced to its simplest expression, and then we shall find, whatever the organization may be, that beauty was waiting for us."[4] His observations sum up the vitality and strength of Amish quilts. A deeper analysis, however, reveals that these design principles are in accord with the religious precepts that guide and shape every aspect of Amish life. To understand the cultural environment that produced these unique quilts, it is necessary to examine first the origins of the Amish people and their place in American society.

II. AMISH SOCIETY: SPIRITUAL AND CULTURAL ROOTS

The Amish communities in the United States are today clustered primarily in Pennsylvania, Ohio, and Indiana.

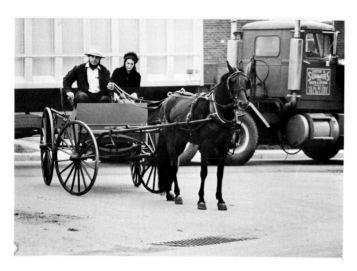

8. A study in new and old transportation.

9. Amish buggies parked at a Lancaster County, Pennsylvania, farmers' market.

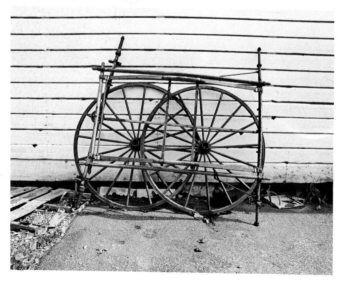

10. Buggy wheels and frame rest against an Amish barn.

Other church districts are scattered from Delaware to Missouri, Oregon, and Ontario, Canada.[5] These people are descendants of the Swiss Amish, themselves a part of the strong Anabaptist movement following the Reformation. The Amish and Mennonite sects were radical reformists who abhorred the alleged decadence and luxury of the Catholic and emerging Protestant churches in Europe. Along with other Anabaptist sects they repudiated elaborate religious garb and ornate churches, opting instead for "the plain and simple style," the ideal being their ascetic vision of the early Christian community.[6]

Jacob Amman, a conservative Mennonite bishop in Switzerland, severed his ties with that church in the 1690s because it was not strict enough in its practice of *Meidung*, or shunning of deviates from the church. His followers formed the sect, later identified as Amish, that migrated to the Palatinate region of Germany and eventually to the United States around 1727. Other waves of Amish followed throughout the eighteenth century and again in the period from 1830 to 1850. Initially, they settled in Berks County and in Lancaster County (then Chester County), Pennsylvania, at the invitation of William Penn, who aided their efforts to flee from religious persecution in Europe.

Today, as in the seventeenth century, the Amish adhere to the principle of nonconformity to the world; they live in it and yet are not "of it." Those outside their community are labeled "the English," and that life-style is avoided as being "of the world." Like their Anabaptist predecessors in Europe, they practice adult baptism, refuse military duty, and often shun those members of their community who openly violate the tenets of their religion.

The foundation of their faith is the Bible: they rely extensively on biblical passages to guide their behavior: "Be ye not conformed to this world, but be ye transformed by the renewing of your mind, That ye may prove what is that good and acceptable and perfect will of God" (Romans 12:2). In an attempt to be nonconforming to the world, they have traditionally rejected such visual symbols of luxury and progress as the automobile, the telephone, electricity, tractors and other power-driven farm equipment, rubber tires, buttons, indoor plumbing, television, and modern fashions. Most tourists who pass through Amish communities notice only these superficial and obvious differences, and do not understand the spiritual basis of their way of life.

To comprehend the special nature of Amish quilts it is helpful to examine the religious and social context in which these quilts evolved. When the Amish arrived in Pennsylvania in the 1720s, they brought little with them except their "spiritual baggage"[7] and the cultural traditions of their homeland. According to Benjamin Rush, the emigrants from the Palatinate carried only a few personal items in a trunk, perhaps some tools and a Bible and basic articles of clothing. One shipload of Germans

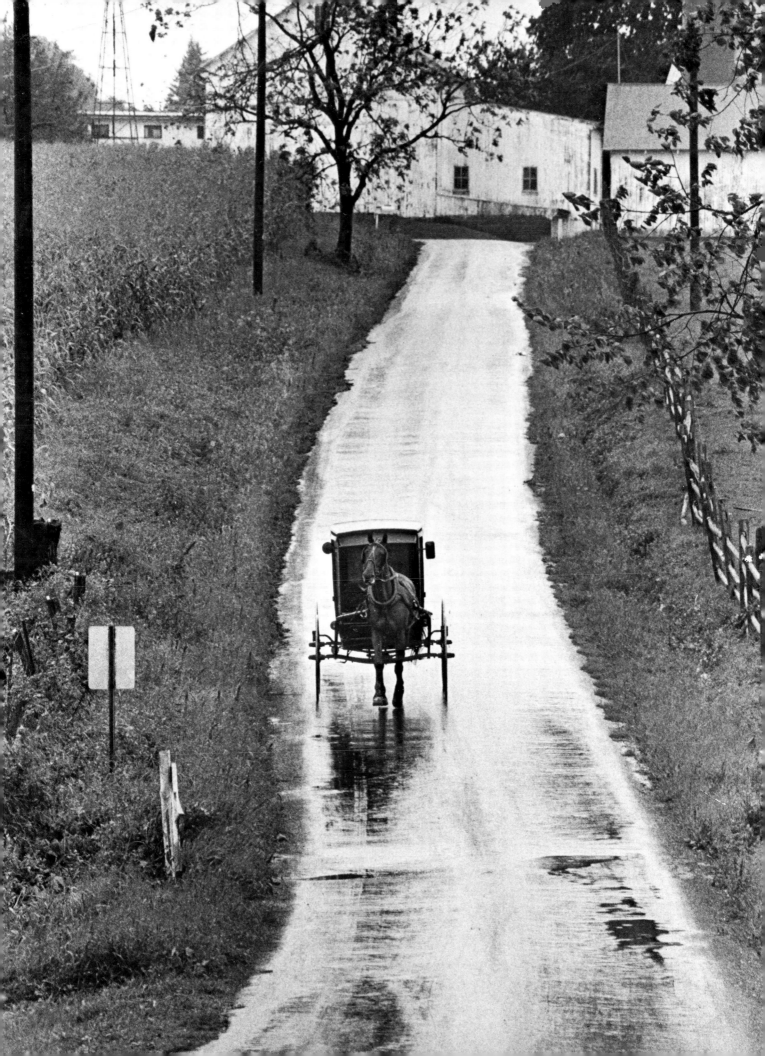

who settled in Lancaster County in 1736 carried, according to *The Colonial Records*:

> . . . four doz. and a half of worsted Caps. Two dozen of printed Linen Caps, Six pairs of worsted Stockings, Four peices (sic) of striped Cotton Handkerchiefs, Twenty-five peices of tape, Two dozen black Girdles, One peice of Bedtick, Two peices of brown Linen, One peice of blue and white Linen. . . .[8]

This group of settlers undoubtedly included non-Amish immigrants, but the inventory is representative of what the Amish would have brought to this country.

It is clear that in the early part of the eighteenth century the Amish were not preoccupied with using a standard mode of dress; the early settlers probably wore a plain version of the costumes of their homeland, but their garb was unusual compared to that of other Pennsylvania settlers of the same era. In 1831 Redmond Conyngham noted in *Hazard's Pennsylvania Register* that Amish men sported long beards and long red caps, while the women wore short petticoats and a "string to keep their hair back, but no bonnet. The dress of both male and female was domestic, quite plain, and made of a coarse material, after an old fashion of their own."[9]

Because the Amish had been so brutally persecuted in their homeland they were eager to settle in homogeneous communities of their own in this country. They moved quickly to Lancaster County, Pennsylvania, where they found enough rich farmland to support their compact but isolated settlements. To preserve their separation from more worldly neighbors, the Amish formed church districts that satisfied most of their spiritual, social, and economic needs. The Amish have never been totally self-sufficient, however; they have always traded with their "English" neighbors to procure farm equipment, staples, medical services, etc. Today, as in the eighteenth century,

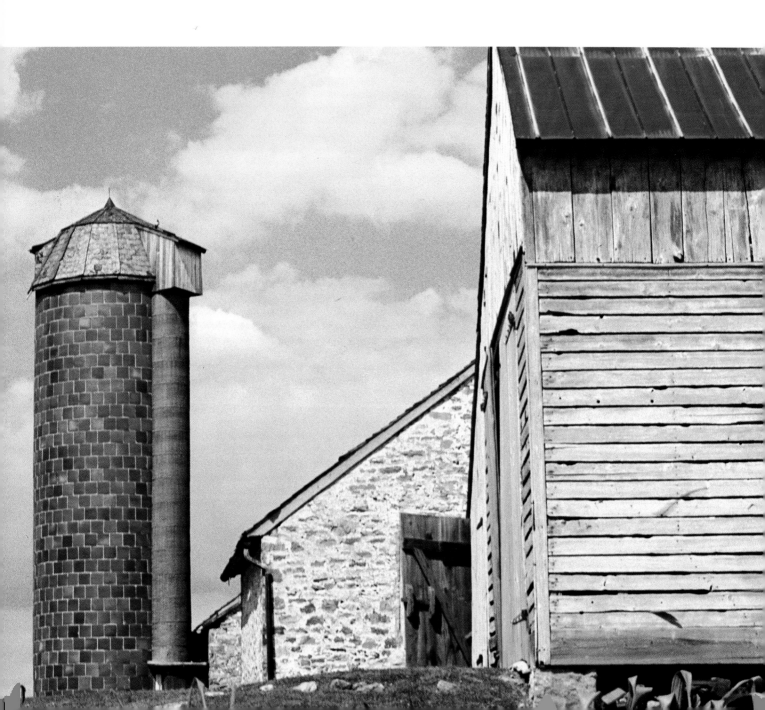

"neither law nor custom draws a rigid and permanent separation between the Amish church and the rest of society."[10] While the Amish have attempted to maintain cultural autonomy, it is easy to observe today the material influences of non-Amish cultures. Amish farms in Indiana, for example, are dotted with rubber-tired tractors, phone booths, and utility poles.

III. AMISH DRESS: THE "PLAIN AND SIMPLE" STYLE

The Amish in Pennsylvania tried to establish geographical and cultural boundaries, but still they came into contact with other settlers—the Quakers, the Mennonites, and the "gay" Dutch who had migrated to this country with them. It is important to distinguish between "plain" Dutch and "gay" Dutch, for it was the latter group that channeled their memories of their Germanic homelands and their joy of life into the creation of vivid green, red, and yellow patchwork quilts, resplendent with tulips and stylized birds—the familiar symbols of Pennsylvania Dutch folk art. While the plain Dutch—the Amish and the Mennonites—reject worldly and, to their mind, sinful material luxuries, the gay Dutch accept the world with both its spiritual and its material pleasures.[11] Thus the Amish interacted more with the Quakers and the Mennonites, sharing their preference for plain, even somber, clothing. Amelia M. Gummere, in *The Quaker: A Study in Costume*, suggests that the Quakers may have modeled their simple attire after the Mennonites, but did not go so far as to condemn buttons or buckles. (The Amish, like their predecessors in Europe, were nicknamed "hookers" in Pennsylvania because they substituted hooks or pins for buttons.[12])

Her conclusion is disputed by later scholars who argue that Quaker settlements were solidly established by 1727, the date of the first wave of Amish immigration. They contend that the Amish, who did not adopt a rigidly prescribed costume in Europe, followed the plain-garb example of the Quakers in this country. Certainly the Amish woman, as described in a 1903 issue of *The Independent*, wore a costume favored by earlier Quakers: an unfringed gray shawl, a brown stuff dress, and a blue apron.

For both religious and sociological reasons, then, the Amish have clung to their plain garb; it is the outward manifestation of their religious beliefs, and it is also a means of maintaining their separation from the world. A primary function of the Amish costume is to provide a concrete and highly visible boundary between the Amish and "the English."[13] This boundary is really a double one: it announces to the world the position of the Amish community, and it provides Amish people with a visible and tangible link to each other.[14] In this sense their costume is a signal to outsiders of the cohesion of the community. The "English" who are confronted with these visual symbols have no trouble identifying the Amish: the conservative or Old Order Amish women wear long dresses with matching aprons, black capes and bonnets, black stockings and shoes, and no jewelry. The men choose black broadfall[15] trousers and short jackets, white or solid-hued shirts, and simple straw or black felt hats with

12 (opposite). Amish farm buildings, Lancaster County, Pennsylvania. Photograph by Barbara S. Janos.

13 (above). The ventilator cutouts in this Amish barn strongly resemble the Fence Row design of the quilt in figure 137.

14. This Amish farmhouse reflects the cultural preference for a plain and simple life-style.

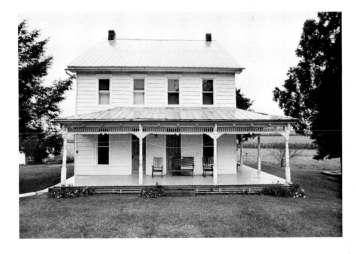

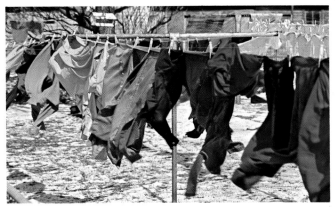

15. Amish clothes, stretching across porches and yards after the traditional Monday washing, show the favorite blues, purples, and greens found in Amish quilts.

wide brims. They may wear one suspender, two suspenders, or none, depending on the degree of conservatism of their church districts. The women's and girl's dresses and the men's shirts are almost always fashioned from solid fabrics; prints and stripes and patterns are frowned on, as they were in Switzerland in the sixteenth century.[16]

The range of hues for dress and shirt fabric is dazzling. One observer described a young Amish girl at a train station in 1872 as wearing a "bright brown sun bonnet, a green dress, and a light blue apron." Another young woman accompanying her was dressed in "a gray shawl, without fringe; a brown stuff dress, and a purple apron."[17] Ann Hark, author of *Blue Hills and Shoofly Pie*, describes an Amish wedding audience in 1952:

> Their dresses, with but few exceptions, were of brilliant colors and the room looked like a flower garden that somehow had been misplaced. The favorite hues were blue and purple-sky-blue, turquoise, navy, lavender, magenta, and deep red—as well as various tones of green and gray . . . each woman wore a full, black apron with a shoulder kerchief of the same shade as her dress.[18]

The nineteenth-century Amish generally favored quieter tones of brown and gray, with an occasional blue apron, while in the twentieth century the Amish have extended their palette with brilliant roses, purples, and blues.

In their choice of colors and fabrics for clothing the Amish have been guided generally by their religious precepts: they have avoided the gay, the fussy, the fancy. The *Ordnung*, or set of rules adopted by each church district, has usually provided unwritten standards of behavior, although until recently it has not specifically limited clothing colors. Some Amish districts, however, have reverted to more conservative styles, and the 1950 *Ordnung* of an Ohio congregation specifies:

> . . . no ornamental, bright, showy, form-fitting, immodest or silk-like clothing of any kind. Colors such as bright red, orange, yellow and pink are not allowed. Amish form of clothing to be followed as a general rule . . . Clothing in every way modest, serviceable, and so simple as scrupulously possible.[19]

Prior to the modern period, however, the regulations of the *Ordnung* were transmitted orally (as they still are in most Old Order Amish communities) and conveyed the spirit of the faith rather than detailed restrictions on dress, hairstyles, fuel, and transportation. Several Amish scholars have commented that this modern trend represents a reaction or defense against threats to the Amish faith. It is debatable whether any of these recent costume restrictions are related to religious beliefs or whether they are simply a sociological phenomenon, a retrenchment in face of threats to the integrity of the Amish community.[20] It is important to note, at any rate, that only since the Civil War has the Amish costume been frozen in its present form; from the earliest years of the Amish faith, the costume evolved gradually, paralleling the garb of their worldly contemporaries, but simpler in form. This steady evolution of clothing styles has had a direct impact on the nature of the Amish quilt; usually assembled from fragments of old clothing, or scraps from sewing projects, the colors and fabrics of the quilt depend directly on the changing tastes in color and materials.

IV. THE AMISH DOMESTIC ENVIRONMENT

A. The House and Garden

The domestic environment of the Amish is another reflection of the simplicity and plainness that they seek in their life-style. Most Old Order Amish homes are sparsely furnished with a preference for wood furniture over upholstered pieces. Patterned carpets are frowned on; an early history of Lancaster County notes that the Amish considered stripes in the carpet to be too worldly.[21] An occasional decorated chest—not uniquely Amish—may brighten the living room and a treadle sewing machine may occupy a prominent place in the work area. Practicality is the primary guideline: windows are shaded by dark green or blue shades but not by fancy curtains or drapes. By the same token, the walls are bare except for an occasional colorful calendar, family record, or felt pincushion, all of which are considered functional.

Any craving for beauty or color is satisfied by highly decorated glassware and dishes, displayed in living room and even bedroom cupboards, by embroidered tea towels, and by quilts. The tea towels are usually embroidered in red thread on white linen with typical "gay Dutch" motifs of tulips and birds and deer. One Amish farmer in his seventies displayed with pride two tea towels, made by his mother in 1918, which were decorated with two types of red embroidery thread. It cannot be argued that the tea towels and the dishes—some never used—have only a practical function, but neither do they constitute a radical departure from the Amish avoidance of worldly goods. The towels and dishes are cherished as family heirlooms or as examples of skilled craftsmanship, but the Amish are not obsessed with acquiring more of these goods.

Amish homes are usually freshly painted, inside and out. The interior walls may be a light or bright blue or green, while the exterior is often white with dark green trim.

The Amish housewife is responsible for the appearance of the yard and garden and spends many hours trimming and grooming it. Brilliant banks of flowers—coleus and marigold and coxcomb—glow against the white buildings; often the flower beds are arranged in neat geometric formations, scrupulously tended to keep their shape.

John Kouwenhoven comments in *Made in America* that men always seek "to arrange the elements of their environment in patterns of sounds, shapes, colors and ideas which are aesthetically satisfying."[22] The neat Amish gardens seem to verify Kouwenhoven's observation, and perhaps the geometric quilts with their neatly pieced triangles and stripes and diamonds are also a reflection of this tendency.

At any rate, Amish women channel a great deal of

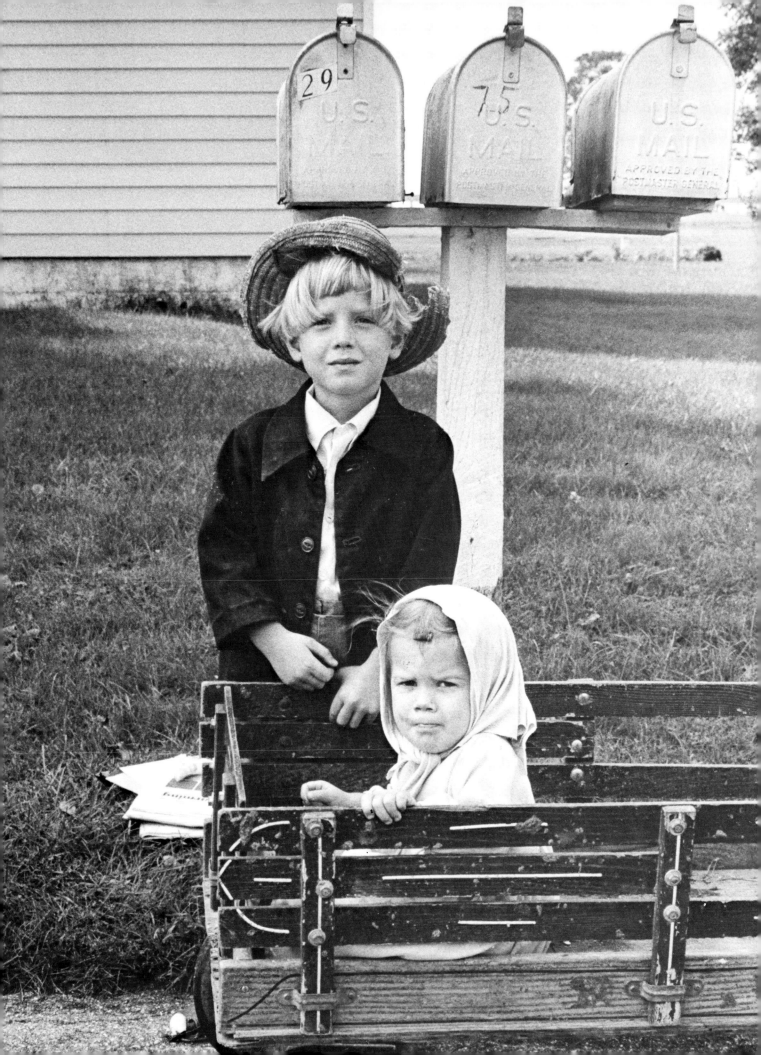

creative energy into the maintenance of their brilliant flower gardens. A woman whose husband spent six months in 1940 working for an Amish farmer was given a tour of the garden by the womenfolk. She remarked, in her husband's diary, that the women were intensely interested in color and were perhaps seeking, in the gardening activity, "a legitimate outlet for the need for color."[23] Another observer, Barthinius Wick, related the case of an Amish woman who was extremely proud of her ability to cultivate flowers and neglected other duties to work in her garden. One day she suddenly realized that this was prideful and therefore sinful, so she destroyed all her plants.[24] This exaggerated concept of sinfulness is rare among the Amish people, but there is a fine variable line between the worldly and the sacred, between pride and modesty. Most Amish women achieve a comfortable balance that allows them to create aesthetically pleasing gardens and tea towels and quilts without violating the spirit of the *Ordnung*.

B. Woman's Place in Amish Society

By tradition Amish women assume a submissive position in a patriarchal society. While they are responsible for the smooth functioning of the household and for the maintenance of the lawn and garden, men make the important decisions in public and economic matters; thus when an "outsider" came to purchase an old quilt recently, the Amish husband remained in the kitchen with the visitor and was consulted when the price was discussed. After the sale was concluded and the women began to discuss the history of the quilt, the husband walked out to work in the yard.

Much of the Amish housewife's activity is fixed routine —raking the yard, husking corn, whitewashing walls, preparing food for Sunday service. She may derive a great deal of satisfaction from accomplishing these tasks skillfully and efficiently, but there may be little to show for her labor. The food will be consumed, the yard will need more attention, the porch must be swept again. Like anyone caught up in routine she may search for some creative activity that has enduring value, whose outcome will be a tangible and lasting evidence of her achievement. The Amish woman has traditionally worked for hours on beautiful quilts that will be passed on lovingly to the next generation.

Many observers have suggested that the manipulation of color and fabric provides the Amish woman with a sanctioned outlet for her creative energies. According to Susan Stewart, "in a culture where life is dressed in somber grays, blacks and deep purples, the quilt provides an interesting contrast as an outlet for color expression."[25] Frances Lichten suggests, similarly, that "quilts . . . were an outlet for love of color and a release for nervous energy."[26] The emphasis may be properly placed on the last term: it is highly conceivable that not all the emotional needs of the Amish woman are satisfied in a community that stresses—even demands—spiritual and material conformity. One can look at Amish quilts, in part, as an unconscious expression of the need for individual achievement, for differentiation.

Some quilts more than others appear to be expressive of this need; they deviate sharply either in color or design from the community norm. These quilts may incorporate unusual colors or they may be pieced in rare, personal combinations of shapes. Often these quilts, in the juxtaposition of blocks of color, convey a strong feeling of tension. In one such quilt, a brilliant green diamond dominates a neutral field of beige or gray. The design lacks the corner squares that normally provide a smooth transition from the inner pattern to the outer borders, so that the observer's eye is arrested by the center of the quilt.

Amish quilts may well embody the tensions that arise from conflicts in the community, between the secular and the spiritual, the practical and the frivolous, between the individual and the powerful church leaders. If an Amish woman chafes against the demands of the community, she must often repress those rebellious feelings to survive. Otherwise she faces ostracism, rejection, even shunning by family and friends. Repressed needs and frustration are sometimes expressed in an excessive interest in cleanliness, in a manicured garden, in an intense quilt. Some of the tensions that pervade Amish society are thus literally "worked out" by needle in elaborate quilts.

V. THE ORIGIN OF THE AMISH QUILT

The Amish women's handicrafts fascinate us, partly because of their simple elegance and partly because we know so little about their design origin. Amish culture is primarily oral and interpersonal, rather than literary, so written records of their domestic activities are rare. The physical compactness of their communities has perpetuated this oral tradition; thus farming methods and recipes and quilting techniques have been passed by word of mouth from generation to generation. It is significant that even the regulations of the faith, the *Ordnung*, have been, for the most part, transmitted orally.

The Amish have developed a "group memory"[27] that has helped preserve the intimacy of their community, but that also denies us much concrete data about the origin of Amish quilts. This problem is not confined to the Amish: John Kouwenhoven notes that we have difficulty tracing the development of a folk art because "no one bothers to note the patterns of colors, shapes and sounds and ideas which plain people produce—at least until long after the patterns have crystallized and have become habitual."[28]

Precise dating of Amish quilts is therefore very difficult and is sometimes complicated further by the inclusion of both old and new fabrics in many quilts. It is wise to give only an approximate date to Amish quilts, as we have done in this volume, and to recognize that the value of these unique bedcovers depends more on the skills

of the seamstress-artist than on the age of the quilt.

The earliest Amish quilt in our gallery, figure 95, dates approximately from the middle of the nineteenth century. This rare pieced quilt contains both home-dyed and commercially dyed materials, and it has several diamond patches of grayish-black homespun next to brilliant red diamonds of stroud cloth, a commercially woven fabric that was used in the 1830s. Although its antecedents are not known, one would guess that the quilt was produced in either Mifflin County or Lancaster County, Pennsylvania.

Although we lack accurate written records, it is reasonable to postulate that the Amish made few quilts before 1860. Some scholars have suggested that Amish bishops prohibited the piecing of quilts in many church districts. Probably the women wove heavy blankets of wool, or they may have stitched together several layers of fabric to form a plain quilt. The authors believe that after the Amish had firmly established their farms and communities, they began to interact more frequently with their non-Amish neighbors; thus the Amish women became aware of American quilting traditions. Borrowing the concept of the pieced quilt from the "English," they began to fashion simple quilts in their own style. Most Amish quilts of the traditional types were produced between 1870 and 1935.

Logically, the primary sources for information on the history and derivation of Amish quilts are elderly Amish women. Many of them have quilted for sixty years or more and were trained to sew and quilt at a time when Amish quilts were at their peak of elegance and refinement. These women—and often Amish men of the same age—can recall early patterns and fabrics and methods of stitching, and they can make important comparisons between the styles of 1910 and the styles of 1970. These women are a vital link with the past and we must listen to them now, for recent generations have not preserved such a lively interest in fine quilting. Through them we can follow the process of quilting from the salvaging of scraps to the final product.

VI. PIECING THE QUILT

According to several Amish seamstresses in Lancaster County, the mother selects the overall quilt pattern (diamond, bars, central square, etc.) often following family tradition. It is not unusual to see a preference for a diamond or a Variable Star quilt passed down through successive generations of a family. Thus one mother in Lancaster County made almost identical crazy quilts for her three daughters, each distinguished by a brilliant heart-shaped patch of a different color. Another mother, in the Lapp family, made basket quilts for her children in 1931, piecing vibrant turquoise baskets in a cranberry field. Several dated, initialed examples of her quilts, in private collections today, are as recognizable as if signed by their maker.

It is customary for the Amish woman to do all the piecing of her quilt top at home. Frequently, it is the older Amish women—the grandmothers and great-aunts—who do this cutting and piecing. They do not have the physical strength for more demanding tasks, yet their contribution to the quilt-making process is greatly valued. In this way quilting is a healthy, integrative activity, for it involves the female members of the family from age four to age eighty; no one feels useless.[29]

Almost all Amish quilts that can be dated after 1860 are pieced by machine; most Old Order Amish households use the foot-powered treadle machine rather than an electric one. One can most easily observe the machine stitches by examining the inch-wide binding; the machine stitching connecting the other pieces or blocks is not visible after the backing is added.

Like many other American quilts, some Amish quilts are pieced in a block pattern. Thus the crazy quilt pictured in figure 77 is actually composed of sixteen blocks, each of which was pieced with patches of various shapes before the individual blocks were joined. This block method was quite popular in the nineteenth century and can be seen in quilts with an overall repeating pattern such as a Log Cabin quilt in the Pineapple design (figure 79). But the central design of many Amish quilts dictates a different approach; the format of a Bars quilt or a Center Diamond would be interrupted by this type of block construction. One notices, instead, that Amish women often piece their bars or wide borders with strips of different sizes. Two or three pieces of mauve cotton, for example, may be used to construct one "bar" in a Bars quilt. This piecing is done to extend the usefulness of a remnant, not out of aesthetic considerations. But this economical use of material, often on the bias, creates some interesting monochromatic effects. Thus a quilt with a pieced black field appears to be composed of many shades of black, some bordering on gray, some shiny and some dull. These color variations often achieved by haphazard piecing, add richness to a basic diamond or bars format.

When the quilt top has been pieced, the filling is added for warmth and sturdiness. Until recently Amish women have frequently chosen a coarse wool filling, uncombed and sometimes unwashed. Moth holes or tears in the fabric of these quilts often reveal bits of this wool that is grayish tan in color. The tiny quilting stitches hold this wool filling securely so that it does not slide around or accumulate in one part of the quilt. Today, most Amish women prefer the practical synthetic fillings manufactured expressly for quilts. They are warmer than wool and wash and dry more easily.

The backing fabrics for Amish quilts, especially in Lancaster County, are often printed with a small check or are sprigged with tiny flowers. A typical turn-of-the-century quilt may have a gray-and-white or brown-and-white checked cotton backing. One possible explanation

for this practice is that the backings are not highly visible and thus do not flout the tradition of solid-colored cloth. The Amish women occasionally buy printed fabric at a local department store and use it discreetly in quilts and comforters but not in clothing. This practice is more typical among the Pennsylvania Amish, though it is now spreading to the Midwest.

The crepe and cotton quilts of the 1920s and 1930s are frequently backed with a plaid or flowered flannel, which increases the warmth and the weight of the quilt. One otherwise sedate Lancaster County quilt has a flannel backing printed with milkmaids and cows and other farm animals—and the maids are not wearing Amish garb!

Even more than the front, the backing material is frequently pieced with strips of various sizes, although they are usually from the same fabric. The backing may appear more worn and faded than the front, perhaps because it is often composed of remnants of old clothing or even old quilts.

When the top and the backing are secured, the quilt is set into a quilting frame, either a square stable frame of wood, which would occupy twenty to twenty-five women, or a rectangular (8' x 2') frame operated by ratchets that enable the quilt to be turned as it is being stitched. The authors have observed both types of frames in the homes of contemporary Amish women. The large frame is quite bulky and occupies much room in the home; one housewife who was preparing for a Sunday church meeting in her home—with forty families expected—had moved her quilt, frame and all, to her sister's home. Obviously, the rectangular frame could not accommodate as many seamstresses as the stable frame, perhaps six or eight. When women work at this type of frame, they begin at the center of the quilt and progress out to the edge, moving the ratchets to turn the material as they work. Novices or unskilled quilters often may sew only when the women have reached the outer border.[30]

Templates or patterns are used to mark the quilt with the exact motifs (rose or tulip and feather) that are going to be stitched. These patterns are usually constructed of a stiff material such as cardboard or tin or even wood. An elderly Amish man showed the authors a template that had been used by his wife's grandmother and passed on to her; it dated before 1880. Made of galvanized, hand-cut tin, it was a simple six-pointed star or flower shape like the template in figure 19. The Amish women trace around these patterns with pencil or chalk or sometimes with the point of a pin, creating a sharp outline in the fabric. Some Pennsylvania quilters dip the metal or cardboard templates in starch, leaving a pattern on the fabric that can be brushed off later.[31]

Experienced quilters may draw the motifs freehand, particularly the border designs—Princess feather or fish scale or cables—that stretch around the entire quilt. Certain women are designated as pattern markers, and gain enough expertise from repeated drawings to work without templates.

Once the patterns are drawn, the quilt owner and her friends begin filling in the design with tiny running stitches. A careful, fussy seamstress can put in twenty stitches per inch. Such fine work was common at the turn of the century, especially when the women worked in wool and cotton; the crepes of the 1930s and the modern synthetics—Dacron and rayon—are smoother and more slippery and aren't conducive to such fine needlework.

VII. THE AMISH QUILTING FROLIC

Most pieced tops are quilted at a bee or frolic, a significant social event in the Amish community. Like many American pioneers, Amish men, women, and children have traditionally gathered to husk corn, build a barn, or stitch a quilt. All of these activities are a form of mutual aid, so important to the preservation of a sense of community among the Amish people. The most dramatic examples of this community effort have enabled countless Amish families to recover from a crisis, such as a fire or a flood. A young Amish couple in Mifflin County, Pennsylvania, victims of the devastating floods of 1972, hosted a frolic where the men rebuilt the front porch of their house and the women finished a pastel Windmill Blades quilt.

Obviously, the frolic satisfies a need for social contact, and this may be especially important for the Amish woman whose responsibilities confine her to the home more than her husband. Gertrude Huntington, a long-time authority on the Amish, describes the women attending a Mennonite Relief Committee sewing bee in the 1950s in an Ohio community:

> At these sewings the women enjoy making quilts in colors they may not use.[32] As they sit around the quilt frames, they have a fine time talking and gossiping. The women move around during the morning, so that almost everyone has a chance to talk to someone else. They discuss their children, the school, the young people, marriages, and pregnancies. As they talk, their fingers fly; sometimes as many as 6 quilts will be finished in a day. After a full, long morning, the quilts that are complete are taken off the frames and the frames dismantled so there will be room to eat. Then the numerous dishes of gayly colored foods are arranged on tables and everyone helps herself, "smorgasbord style."[33]

While Relief Sewing is frowned upon in the more conservative Lancaster County communities, the quilting bee is very much alive. Katie, a skilled seamstress nearing eighty, tells a charming tale of neighborly helpfulness on a hot summer day. A large group of women had gathered to quilt and in the course of the morning finished three tops. After lunch three of the women decided to walk home; en route they passed the house of a young woman about to be married. Finding no one at home, they walked in and saw the prospective bride's unfinished quilt on a frame. In three hours they completed the quilt, walked down the road, knocked at the door of another friend and proceeded to finish her quilt too!

The Sugarcreek, Ohio, *Budget*, a newspaper catering

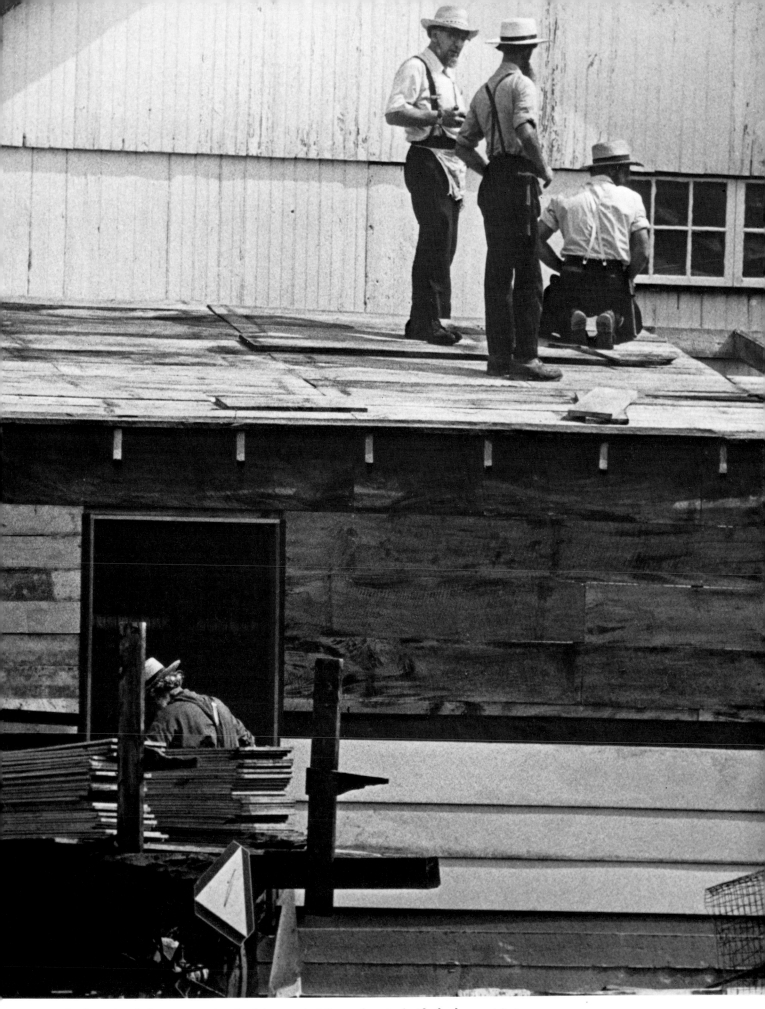

17. These Amish farmers are involved in a typical form of mutual aid, the barn raising.

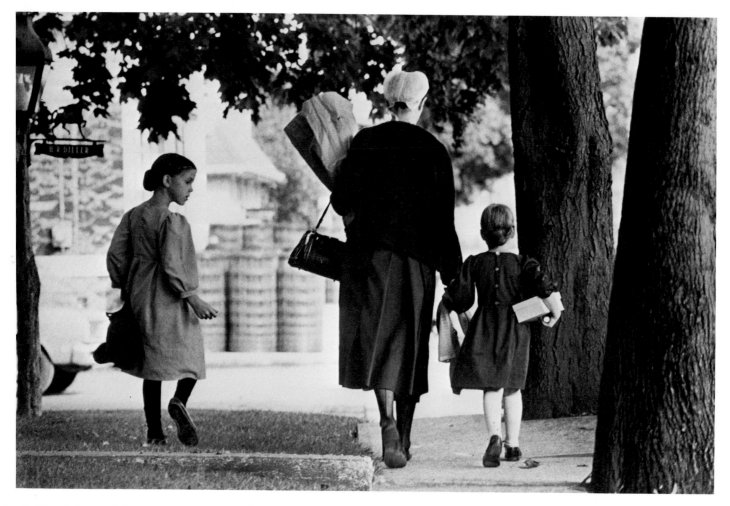

18. The clothing of this Amish woman and her daughters shows some worldly influences: shorter skirts, buttons, and modern handbags.

to the Amish, provides a fascinating record of quilting bees dating back to 1890, its first year of publication. A substantial portion of each issue of the paper is devoted to letters from various Amish church districts, reporting the weather, farm activities, illnesses, and the constant visiting of the people. The letters provide some data on the "where and when" of Amish quilting bees, but rarely make a personal comment on the activities or on the meaning of Amish quilts. (In fact, almost all contemporary Amish would say that their "meaning" lies in their practical value.)

Thus a correspondent from New Wilmington, Pennsylvania, noted on June 30, 1898, that "there was a quilting party at the writer's home last Wednesday. There were 25 here for dinner and supper." A more personal note is sounded by Mrs. E. D. Miller of Daytonville, Iowa, who reported in 1901 that "There was a quilting today at Jacob Grunden's, but on account of a badly sprained foot I was unable to attend. The worst was I hated to miss the good dinner."

Many times quilting is mentioned briefly when the writer lists the major activities of the church district. Thus in 1922 a *Budget* contributor from Bird-in-Hand noted that "tobacco stripping is the go by the men, sewing and quilting among the women." That same year an Amish lady from Hollsapple, Pennsylvania, wrote that

"the women are busy quilting nowadays, the writer was quilting all week. Andrew Baumgardner had quilting on Tues and Weds."[34]

This Ohio newspaper also carried advertisements from local dry goods stores that specialized in "plain wear" or solid-colored materials. In December 1921 such an ad promised low prices for plain-color twill, "grey, purply, navy, khaiki." In a 1923 issue a large ad mentioned remnants of all solid colors; this date roughly coincides with the time when Amish women began purchasing material just for making quilts. In 1939 cotton sheeting, made expressly for quilting, was advertised at special low rates of 29 cents for an 81-inch length, and 35 cents for a 90-inch length. Some Ohio Amish quilts made in the 1920s and 1930s have backings stamped with the sheeting manufacturer's name.

In June of 1923 an Indiana writer reported that "yesterday there was a barnraising for the men and a quilting for the women at the home of Sem K. Eash; I was told there were 225 with the children." The women probably worked on several quilts at once because of the unwieldy number of sewers available.

Entries in the *Budget* in the 1960s and 1970s are scarcely distinguishable from those at the turn of the century. Quilts are mentioned more frequently—although still with little personal commentary—and the writers are

usually women. A lady from Conewango Valley, New York, noted in 1956 that "Joseph B. Yoders had a frolic to put up a buggy shed on Thurs. The women quilted." In January 1975 Mrs. John Martin of Goshen, Indiana, wrote that "the granddaughters of Barbara Weaver helped her with quilting one evening recently. She told them of her childhood home in Iowa, which made it an enjoyable evening." Anna Fisher of Christiana, Pennsylvania, reported in May 1975 that "Sister Katie had a quilting on Thurs. She invited Ben's Sammie Si Katie and daughters, David Zook's Beckie and daus . . . 27 people at least. Sammie Si Katie is still walking with crutches." This letter also reflects the Amish preoccupation with health; next to farming and visiting, it occupies much space in the *Budget* letters.

A letter from Tunas, Missouri, dated June 4, 1975, indicates a new development. "There's no slump in the quilt business. Mrs. H. Stauffer has more work than she can handle. Some people bring quilt tops that have laid in drawers for many years or more. They are yellow with age and must be handled carefully lest they tear while one is working on them." Many Amish women today are augmenting the family income by quilting old and new pieced tops and selling them from their homes. Often, one woman who is not reluctant to deal with outsiders will serve as an agent for Amish seamstresses and will sell all their quilts—usually new ones—on commission. One busy woman in Lancaster County has stacks of these quilts in her living room in gaudy hues of purple and yellow on fields of white. When asked for old Amish quilts, she produced several done about ten years ago in more traditional tones of blue and purple and brown. Finally, she located an antique Amish quilt that was carefully buried at the bottom of the pile and priced at $300, about double the cost of the new quilts.

VIII. THE DYES AND MATERIALS USED IN AMISH QUILTS

One can learn a great deal about the age of an Amish quilt by determining what dyes—natural or commercial—were used to color the fabric.

In the nineteenth century and again during World War I Amish women often dyed their own cloth, preparing their dyes from the weeds and berries and barks native to their environment. According to Rita Androsko, "A complete palette of yellows, golds and browns [could] be created from the products of roadsides, forests and gardens."[35] An early observer, Redmond Conyngham, noted that the Lancaster County Amish settled in a fertile area "beautifully adorned with sugar maple, hickory and black and white walnut."[36] The barks of these trees and others were the main ingredients of simple home-made dyes. Homer Rosenberger reports that early German pioneers dyed homemade cloth brown with the bark of the butternut tree.[37] Other tree barks used in brown dyes were hemlock and alder, which produced a reddish brown if combined with alum mordant. According to Androsko, sometimes the women boiled their brown dyes in an iron kettle, dissolving enough of the iron to create a black dye. This also released the mordant to

make the dye fast, but in doing so it caused a more rapid deterioration of black and brown fabrics.[38] As a result, early quilts constructed of home-dyed cloth may contain blue patches in excellent condition and brown patches that are worn or even shredded.

Yellow dyes were frequently created with goldenrod and with the bark of black oak, both very common in Pennsylvania. Sassafras, used for dyes in the Philadelphia area in the nineteenth century, also produced light brown and ash colors. Madder was the primary source for reds; pokeberries could be used for a purplish red but produced a weaker, impermanent color. Homegrown madder was easily prepared, yielding a popular shade called "turkey red."

American homemakers relied on natural indigo dyes until the last quarter of the nineteenth century, when it was synthesized, because it produced a clear strong color and could be combined with yellow dyes such as goldenrod to produce green shades. Natural indigo was harvested in great quantities on the East Coast, particularly on several islands along the Delaware River, and was thus easily obtainable by the Amish.

Some dyes, such as cochineal (red), were manufactured commercially and could be purchased at the apothecary or at the general store, but Amish women rarely relied on commercial dyes. Although the end of the age of natural dyes occurred with the synthesis of a lavender dye in 1856, the Amish lagged far behind the general populace in their acceptance and appropriation of many modern conveniences.

When examining the Amish quilts of the period from 1850 to 1870, it is important to remember that unique colors result from the natural dyes they used. Dye lots are never identical, and the home dyer can produce interesting, subtle color variations. If a stack of old Amish quilts is examined, it is almost impossible to find one color duplicated in another quilt. This shading may also be due, in part, to varying degrees of wear in the fabric before it is cut up for the quilt and, in part, to fading from the sun or repeated washings. Very few examples of home-dyed Amish quilts have survived, due to constant wear and to the small number of Amish quilts made before 1870.

There has been an evolution in the types of material used by the Amish which roughly parallels their integration with the non-Amish community at large. The early settlers from Krefeld on the lower Rhine who migrated to Germantown in the early years of the eighteenth century were renowned for the fine quality of their wool and linen weaving. Homer Rosenberger notes that these German pioneers made linsey-woolsey—a coarse linen and wool cloth—and used it for clothing.[39] There is some indication that the non-Amish weavers who settled in Germantown continued to produce the patterned textiles of their homeland,[40] but it is unlikely that the Amish produced anything but plain coarse cloth, for utilitarian rather than decorative purposes.

Until the twentieth century all Amish clothing was made in the home, often from scratch. Some housewives

prepared their own flax for weaving, a very tedious process, or had it sent out to professional weavers. Because the Amish community was so compact and homogeneous, the women could depend on weavers located within their own district. Frequently they took their unprocessed wool to a weaver who washed it, spun it, and dyed it yellow, brown, black, or red. Britain took steps to discourage an American textile industry, but largely ignored these local operations that produced cloth for home consumption.

The Amish women gathered their materials for quilts from several sources, the primary one being used clothing or remnants from other sewing projects. As Frances Lichten notes, "women unconsciously developed into artists in salvage,"[41] and they utilized every precious scrap from an old purple apron or boy's blue shirt or from a faded black cape. Some Amish quilts of the early twentieth century even include scraps of upholstery material removed from furniture they had purchased second hand. One Amish woman in her eighties, still an active quilter in Lancaster County, describes certain quilts as being "quilts to use up." She is referring to bedcovers like the crazy quilts that are often considered aesthetically exciting today, but that originally evolved out of economical, frugal measures. The crazy quilt thus provides an outlet for the contents of the scrap bag, usually gathered over many years.

At the end of the nineteenth century Amish women began purchasing fabrics for clothing and quilts at special stores that catered to the Amish trade. Located at the center of densely populated Amish communities in Lancaster County, Pennsylvania, Holmes County, Ohio, and Lagrange County, Indiana, these dry goods and department stores displayed—and still display—roll upon roll of solid-colored fabric: "bolts of dull-finished cotton fabrics in kelly green, yellow, red, royal blue and soldier blue, purple and plum."[42] The non-Amish shopper is amazed at the varieties of black cloth, some dull and heavy, some lightweight and shiny, some coarse, other rolls fine and expensive. In 1958 Spector's Stores, specializing in Amish goods in the Midwest, advertised "summer lawn and voiles, fine mercerized fast color Pink, Aqua, Orchid, Rose, Maize, Peach, Dark Green, White, Navy, Dark Brown, Dark Wine, Dark Gray, Turquoise, and Black. Sale Price, 35 cents per yard."[43] This rainbow of choices immediately brings to mind the Amish Sunshine and Shadow quilt, composed of small patches in perhaps twelve or fourteen solid colors. Called Grandmother's Dream or Trip Around the World by the non-Amish, this quilt is a concrete embodiment of the polarization inherent in Amish society—the dualities of light and dark, good and evil, the worldly and the spiritual. The patches are usually arranged so that rows of light-colored diamonds are followed by rows of somber diamonds, just as if the bright patches were casting shadows. Walter Boyer, in an article in *Pennsylvania Folklife*, argues that this careful balancing is seen "throughout all motifs of folk art and is the core of the culture's world view. Duality is seen in the midst of unity . . . The day is one, but the light of day is better than the dark of day."[44] Jonathan Holstein suggests that such quilts are inspired by Near Eastern mosaic design patterns,[45] but this is not inconsistent with the possibility that quiltmakers instinctively found the balance between light and dark to be pleasing.

Although Amish people have rarely bothered to give names to their quilt patterns the appellation Sunshine and Shadow sums up the realities of Amish life. On one level, these people may be deeply satisfied by their rich farm life and the warm fellowship of the church community, and by the hope for eternal life, but shadows constantly intrude in the form of farm accidents, deviant or rebellious children, and of course death. On another level, religious discipline demands that these people avoid the world—the shadow—and pattern their life after scriptural examples—the sunshine.

Observers who have a superficial understanding of the Amish faith may argue that the shocking hues of many Amish quilts contradict the Amish principles of plainness. It must be remembered that the *Ordnung*, or rules of conduct, do not specifically refer to quilts or other forms of art. As mentioned before, within narrow limits the Amish woman may exercise a great deal of freedom and personal control over the "shape" of her quilt. Gertrude Huntington observed in an Ohio community in 1957 that the church allows the individual "to do and think as he pleases as long as it does not do harm to the *Gemeinde*,[46] (the spirit of fellowship that binds a community), although she adds that the church may be more concerned about visible behavior (dress, transportation, etc.) than about thoughts and feelings. She also warns us that fluctuations in the application of the *Ordnung* from district to district make it difficult to generalize about cultural prohibitions.

Knowing about the culture one could deduce that

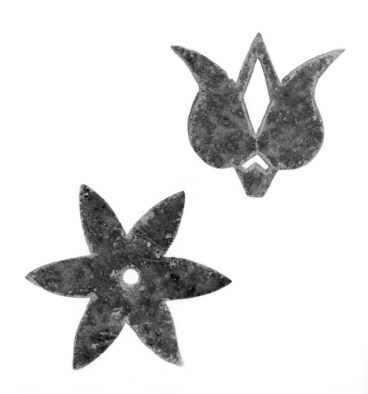

there might be certain colors or shades that were forbidden, but it is impossible to know just which these are until they are observed. In the same way one knows that there will be regulations about house furnishings, but it is only by being told or observing that one learns that cupboards with glass doors are forbidden downstairs but allowed upstairs and that cupboards with frosted glass doors are allowed even downstairs.[47]

Her warning can be directly applied to Amish quilts: while custom and religion have combined to produce a basic type of quilt, actual practice has produced fascinating deviations from the norm.

IX. THE ORIGINS OF AMISH PIECED AND STITCHED DESIGNS

As fascinating as the offbeat colors of Amish quilts are the strong and simple designs. As is usual with pieced quilts, the tops are composed of abstract geometric shapes that are almost always straight edged. It is very difficult to piece round or curved shapes because of their tendency to pucker; it is much simpler to join two straight edges.

Amish quilts are composed of three primary shapes, the square, the triangle, and the rectangle. The use of the square may range from the center square dominating the field of the quilt to smaller blocks placed in the corners of quilts, to tiny patches forming a double nine-patch of a Sunshine and Shadow design. The combinations of the basic elements are numerous: very often the square is placed on its corners to form a diamond, and the diamond itself may be embellished with triangles along the sides, resulting in a sawtooth diamond. Long rectangles appear in pure form in "Bars" quilts, and they are found in almost every other type of quilt as wide borders. Small triangles may be arranged to create sawtooth effects, larger triangles are usually placed around diamonds to complete a square. In Amish quilts from Ohio and Indiana, particularly, triangles are joined to form basket, star, or bow-tie motifs.

19 (opposite). These well-worn, hand-cut tin templates were used by Amish seamstresses in the late nineteenth century.

20. Amish women can choose today from a broad range of bright cottons and synthetics for clothing and quilts. These fabrics, priced at $1.19 a yard, are displayed at Spector's Store in Shipshewana, Indiana.

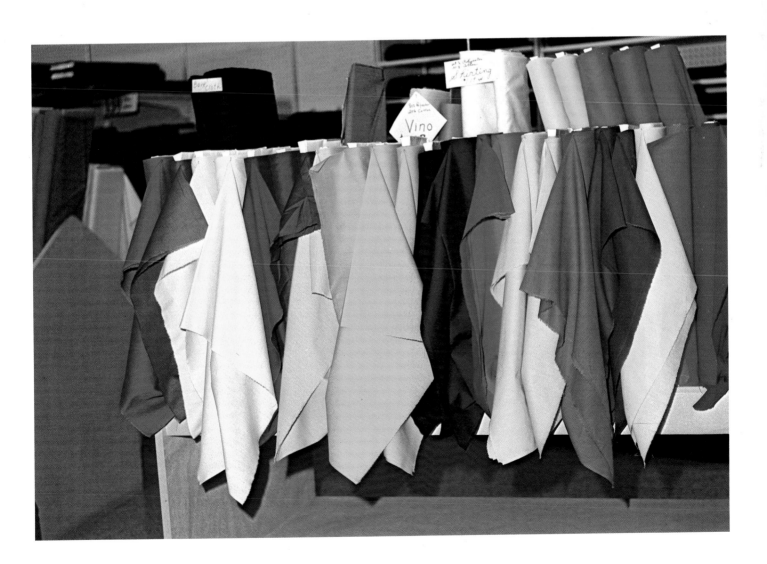

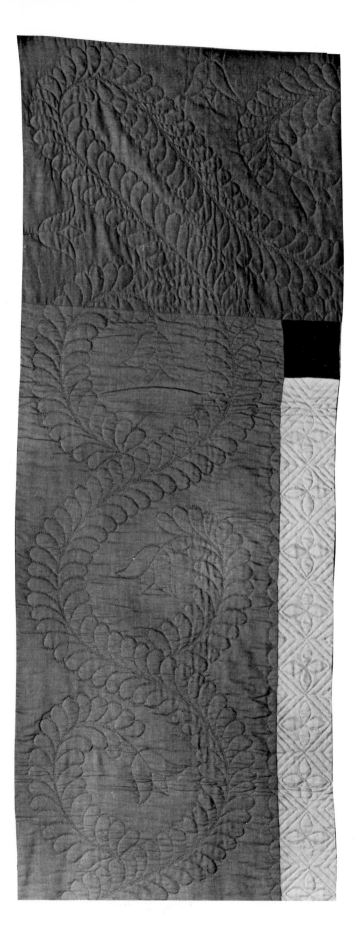

21. This detail from a Center Diamond quilt contains three favorite motifs: the Quaker feather deeply looped in the corner, the tulip, and the "pumpkin seed" flowers of the light-colored inner border at the right.

The simplicity of the Amish pieced compositions is influenced by religion as well as practicality. Averil Colby comments in *Patchwork Quilts* that the total number of tiny pieces in a quilt was a source of pride to the seamstress.[48] Partly because excess pride in worldly possessions is considered sinful in Amish society, the early Amish quilts are almost uniformly constructed of large simple pieces. It is only at the turn of the century that more intricately pieced formats such as the Sunshine and Shadow, Variable Star, and Sawtooth Diamond have emerged.

What is the inspiration for the designs of these pieced quilts? While the Palatinate women carried to this country a tradition of fine bedcovers, there is no evidence that they pieced and quilted similar abstract geometric bedspreads in their homeland. Patsy and Myron Orlovsky suggest that ordinary household objects—wallpaper and textiles and china—were a source of inspiration for American quilt designs.[49] The Amish women, of course, were not surrounded by fancy textiles or wall coverings, and they had no access to the popular books and magazines that featured quilt patterns as early as 1840. But every Amish home had an *Ausbund*, the Amish hymnal printed in Switzerland in 1564 and in Germantown, Pennsylvania, from 1742. The *Ausbunds* printed in the seventeenth, eighteenth, and nineteenth centuries were bound in leather, with brass bosses (raised ornamentations) to protect the book from excessive wear. Early Dutch and German settlers in Pennsylvania, especially Germantown, created bindings in the style of their native land, often following medieval forms, with metal bosses and blind-tooled leather.[50]

One is immediately impressed by the fact that the shape and placement of the brass bosses almost exactly resembles the basic design of a pieced Amish quilt! Thus one *Ausbund* printed in 1767 has brass corner squares and blind-tooled lines forming inner and outer borders, which connect the corner squares, much like a Center Square Amish quilt. Even more striking is an *Ausbund* printed in 1801 that has not only the same brass corner squares but also a center diamond of brass, the exact outline of a Center Diamond quilt. On the 1801 binding both the brass center diamond and the corner bosses are embellished with raised wreaths that are very similar to the stitched wreaths often found on Amish quilts. Other *Ausbunds* are decorated with variations of the center square or the center diamond, sometimes trimmed with sawtooth tooling. Scroll designs are frequently blind-tooled on the borders of the bindings; these motifs are strikingly similar to the elegant stitching found in the borders of Amish quilts.

Families often passed these hymnals down through the generations, and it seems reasonable to conclude that an Amish seamstress, perhaps unconsciously, would adopt the overall design for her pieced quilt from these old volumes. Probably she constructed paper or cardboard templates of these basic geometric shapes, adding sawteeth or wreaths or scrolls as time and custom allowed.

Other explanations of the basic design of Amish quilts must also be considered. The Amish were not the first culture to construct a quilt in the center-square or framed-medallion style; fine English quilts of the eighteenth century often feature a center square or center diamond, sometimes edged with sawteeth, and flanked by several borders—a frame within a frame. In essence, these quilts are composed of squares, triangles, and bars. It is unlikely that the Amish had direct exposure to the early English quilts, but the source of their inspiration was probably similar: simple household belongings such as textiles or leather-bound books, and in the case of the English, oriental carpets and tapestries.

Several Horse and Buggy Mennonite quilts, dated about 1850, strongly resemble early English quilts, incorporating both the framed-medallion format and pieces of chintz in the sawteeth and the nine-patches. This group of Mennonites is the closest spiritually to the Amish, sharing their disdain for fashionable clothing and modern conveniences. It is difficult to tell if the Mennonites were influenced by the Amish in creating this type of quilt, or vice versa, but there was certainly more social intercourse between these two sects than between the Amish and the "gay" Dutch. However, most Amish quilts are easily distinguishable from Mennonite quilts; the Mennonites are generally less conservative and isolated, and their bedcovers may be fashioned of fabrics with small prints or checks, and they frequently contain many more pieces than the early Amish geometrics.

Upon close examination one notices that Amish quilts are covered with intricate stitched designs and motifs, all done by hand. In fact, it would be impossible to duplicate this fine stitching by machine. Among the common quilting patterns are diamond or "waffle" grids, scallops or fish scale, primitive tulips, roses, feathers, and wreaths. Center Diamond quilts are often embellished with an elaborate wreath or star in the center of the diamond, and almost all Amish quilts have a wide border decorated with stitched feathers, cables, tulips, or baskets.

By placing a brightly appliquéd "gay" Dutch quilt next to an Amish quilt, one can see that if the Amish quilt's stitched designs and motifs—hearts, stars, tulips, and feathers—were replaced by appliqués, it would strongly resemble the "gay" quilt. The intricate Amish stitching is an acceptable way of incorporating the same designs without violating the spirit of the *Ordnung*.

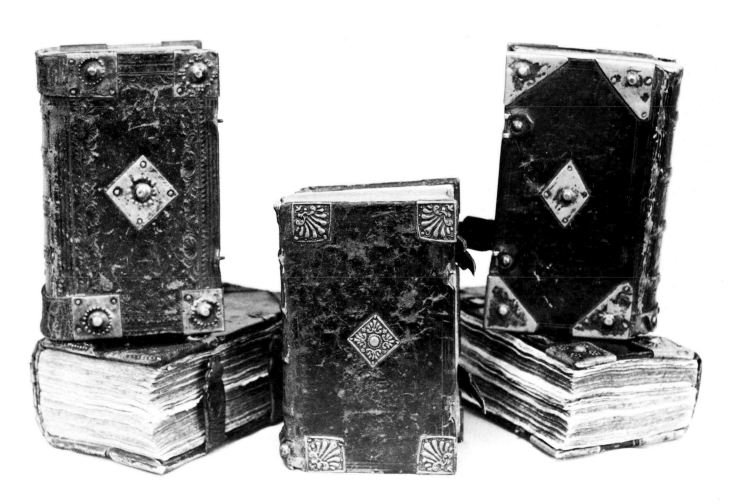

22. These Amish *Ausbunds* (hymnals) were printed in 1767 and 1801. The brass bosses and the tooled designs on the leather bindings are very similar to the pieced and stitched designs of some early Amish quilts.

The motifs that appear both in Amish quilts and in the "gay" Dutch quilts have common roots in European arts and crafts, although as Eleanor Whitmore emphasizes, every culture treats these motifs in an individual manner.[51] Thus the Amish principally confine the hearts and flowers and birds to their stitched patterns, while other Swiss and German sects cover not only textiles but also dower chests, *frakturs*, and household utensils with these gay folk designs.

When Amish settlers arrived in this country in the early part of the eighteenth century, they brought little with them except clothes and tools. They probably did not bring actual models or patterns of folk art to their new settlement, but relied instead on memory to translate their European artistic heritage into similar, though often simpler, forms. Economic conditions and physical hardships, as well as their religious tradition, dictated simpler crafts and tools and bedcovers. John Joseph Stoudt, in *Sunbonnets and Shoofly Pies*, examines the changes that peasant arts undergo when transferred to this country. "This new frontier made new demands. People who had been trained in the best European guild system were here forced to work as primitives again; they were forced to go back to older ways and repeat the work history of the race."[52]

Stoudt also argues that the "spiritual baggage" of the German settlers was more important than material possessions or models for folk art. He contends that the religious images expressed in the Scriptures, in hymnals, and in prayerbooks are the source of the common motifs we see in Pennsylvania German art. Though he refers primarily to the "gay" Dutch culture, some of his conclusions may be applied with caution to Amish society and Amish artistic endeavors.

In *Pennsylvania German Folk Art: An Interpretation* Stoudt examines the rich imagery of the hymnals, the constant evocation of Christ through the symbolic use of the rose, the heart, the star, the diamond, and the tulip. Thus the flower in Pennsylvania German folk art usually represents Christ; one hymnal refers to Christ as "the Rose of the Heart."[53] The tulip, a common motif in Amish quilts, is really a popularized form of the lily, which is a recurring symbol in early Christian art. Many pious separatists and mystics, including the Mennonite and Amish sects, considered the lily to be "the sweet-smelling tulip of Paradise."[54] The New Testament praises the "tulip-lily" in the following passage, a favorite among Pennsylvania Germans:

Consider the lilies of the field, how they grow; they toil not, neither do they spin: And yet I say unto you, that even Solomon in all his glory was not arrayed like one of these.[55]

Similarly, the heart has spiritual rather than sentimental significance for these sects. Stoudt claims that the heart is a symbol of God's heart, Jesus, "the heart of man's nature."[56] Although some maintain that an Amish quilt decorated with stitched hearts is a bridal quilt, our research contradicts that conclusion. Stoudt, Lichten, and others argue against the romantic interpretation. Amish seamstresses have also denied that the use of the heart motif has any special significance; they claim that it has the same value as other motifs, and in fact, there may be no such thing as an Amish bridal quilt. Traditionally, the Amish bride has a trunk full of coverlets and quilts, but no one quilt is singled out as being *the* bridal quilt.

Diamonds, as we have already noted, frequently appear in pieced form or in stitched patterns in Amish quilts. In the Bible used by the plain sects Stoudt has found several references to Christ as the "cornerstone," and the German word may also be translated as "diamond."[57] A religious interpretation of the meaning of Amish quilts would suggest that just as the central diamond is the focal point of the Amish quilt in which it appears, so Christ is the focal point of the household in which the quilt is used.

It would be a great mistake, however, to conclude that the Amish purposely transferred these symbols of their religious faith to their quilts. After years of exposure to this rich religious imagery—and to little else—it would be very natural for them unconsciously to use these familiar symbols. The Amish quilt should not be considered a religious object: it is simply a functional item whose decoration reflects the spiritual orientation of Amish society.

X. GEOGRAPHICAL AND CHRONOLOGICAL EVOLUTION OF THE AMISH QUILTS

The Amish quilt underwent a number of changes as the plain people migrated from Lancaster County, Pennsylvania, to other parts of Pennsylvania and eventually to Ohio, Indiana, Iowa, Illinois, and Missouri. The Lancaster County Amish quilt, like many Amish communities there, tends to be more conservative than those made in the Middle West. Typically, it is rendered in subtle, mellow colors and earth tones, with a one-inch outer border in a contrasting color. If it has a dominant center design, it usually has corner squares and often an inner border. The majority of Lancaster County quilts were made of wool, even into the twentieth century, while cotton is more commonly used in Midwestern Amish quilts.

Toward the end of the eighteenth century groups of Amish families migrated from Lancaster County to Mifflin County, Pennsylvania, north of Harrisburg. The quilts that evolved in this community do not retain the traditional Lancaster County designs of uncluttered diamonds, bars, and center squares. The women of the "Big Valley" of Mifflin County preferred more vivid colors and overall repetitive patterns such as tumbling blocks, bow ties, and baskets.

An elderly Amish carpenter in Belleville, Mifflin County, showed the authors two old quilts he had tucked away in a chest. One was made by his grandmother in 1870, and one was stitched by his wife at the time of their marriage in 1918. The newer quilt was constructed of dark purple cotton with pieced orange baskets, a strik-

ing composition framed with a thin border of gray cotton. It was finely stitched with feathers and small wreaths, all in all a superb example of a Mifflin County quilt. The carpenter, a widower, treasured this quilt and openly regretted that he had parted with other family heirlooms.

Amish quilts have also been found in Mercer, Somerset, Lebanon, and Berks counties in Pennsylvania; most of them are closer in design and color to Mifflin County quilts than to Lancaster County bedcovers. Quilts made in Berks County, the site of the earliest Amish settlement, have frequently included small pieces of patterned material.

There was a great deal of interaction between Amish church districts across the state of Pennsylvania, as letters in the Sugarcreek *Budget* verify, so one can expect reciprocity in quilt patterns and techniques. The historian's task is complicated by the fact that a quilt found in a Mifflin County dower chest may have been transported from Lancaster County some forty years earlier.

In 1807 Amish pioneers moved west to Holmes County, Ohio, and in 1842 other groups settled in northern Indiana, establishing lasting communities there. Amish women in these church districts have always quilted too, although their quilts can be distinguished on several counts from those of Lancaster County. Often they are fashioned of brighter colors than their Pennsylvania counterparts, with more yellow and pink, perhaps combined with navy blue, and with extensive use of black fabrics. A typical Ohio quilt might have a field of shiny black cotton with pieced stars or windmill blades of turquoise or deep blue or maroon. It is very rare to find a Lancaster County quilt with a predominately black field. This difference must be attributed to simple preference, crystallized over the years into tradition, rather than to any strict religious tenet.

Ohio Amish quilts often deviate from the traditional Lancaster County, Pennsylvania, patterns. Variable Star, Windmill Blades, Stars and Stripes, Ocean Waves, and other repetitive patterns are much more popular in Ohio quilts for several reasons. In the first place, Amish families frequently left Lancaster County because of religious differences, perhaps after some split over the *Ordnung* or the *Meidung*. In most cases the splinter group wanted to establish a less conservative religious community, and this desire is reflected in their style of living, their clothing, and their art. Many Amish families in Ohio and Indiana have begun to use the telephone and rubber-tired tractors, and may have electricity run into their farms. The men in these communities tend to have shorter hair, the women may wear sweaters or short coats, and buttons are used. Likewise, Midwestern seamstresses have not felt compelled to cling to the traditional designs of the conservative communities they have left.

Another, and probably more significant, factor is that the Amish in the Midwestern states are often not densely concentrated within a church district; many of them have "English" neighbors and are constantly exposed to worldly ways. Their quilts frequently incorporate the patterns, colors, and fabrics of their non-Amish neighbors, while the Lancaster County quilts are conceived in greater isolation from the outside world's influence.

One outgrowth of this evolution is that Amish women in the Midwest engage in Relief Sewing, preparing clothes and quilts to be sent overseas by the Mennonite Central Committee. Women in Stonyrun, Ohio, for example, assemble once a month at an Amish home, work on quilts or comforters, and stop for a delicious potluck lunch. Although Relief Sewing is a fairly recent development, the Sugarcreek *Budget* of January 6, 1921, notes that "today the sewing circle met at the home of Mrs. Sam Miller [of Midland, Michigan] and quilted one quilt and made several articles for foreign relief."

On the whole, Indiana Amish quilts are very similar to Ohio quilts, predictable since both states include many Amish who have forsaken the Old Order sect in Pennsylvania. Indiana Amish seamstresses, like their Ohio neighbors, favor small overall patterns and much navy and black material. Several stunning quilts seen in the Goshen area, made about 1920, use small diamond patches of white and black cotton in a bright blue field to create exciting optical effects. The diamonds seem to shimmer like tinsel Christmas strips.

An exception to this progressive trend occurred in the conservative church districts of Daviess County, Indiana. According to an Amish scholar, David Luthy, in the nineteenth century the bishops in this county forbade Amish women to construct pieced quilts![58] They were allowed to make quilts only of two pieces of whole cloth plus the filling, although fine quilting was still allowed to secure these layers.

In the United States such quilting limitations were confined to a few counties in the Midwest (Buchanan County in Iowa, Daviess, Allen, and Adams counties in Indiana). According to a young Amish woman now living in Ontario, this practice was still alive, but not as strict, in Holmes County, Ohio, in 1960, where young women traditionally received four quilts before their marriage: three pieced quilts and one "plain" or unpieced quilt.

Several large groups of Amish who have emigrated to Aylmer, Ontario, from many parts of the United States continue this conservative custom today. The women of these recently established communities construct solid-color, unpieced quilts of aqua or green cotton, avoiding the brighter shades of pink or yellow or red. Usually they embellish the center of their quilts with a carefully stitched wreath or star.

Besides the geographical development of quilts following the Amish emigration westward, Amish quilts reveal a marked evolution in the use of fabrics. Until about 1925 or 1930 most Pennsylvania Amish quilts were made of wool, desirable because it could be evenly colored with natural dyes. At the turn of the century cotton was also used frequently, either alone or combined with pieces of wool. In the second quarter of the twentieth century crepes appeared; mauve and green and purple crepe were

often combined with cottons in Diamond and Bars and Sunshine and Shadow quilts. From this time on the Amish housewife relied on "store-bought" materials for her quilts and gradually shifted from the more expensive wools and cottons to the synthetics—rayon and Dacron—which are bright and shiny and easily laundered. But these quilts can be disappointing on several counts. The slick synthetic colors lack the glowing saturated quality of wool and even cotton; these new quilts, by comparison, are sometimes gaudy and showy, not warm and rich like their turn-of-the-century prototypes.

Other changes in the nature of the Amish quilt involve a widening of their color spectrum and an increasing complexity of their pieced design. Quilts of the past forty years sometimes contain white material, which was previously frowned on for both practical and religious reasons. Quilts examined in Amish homes illustrate this gradual evolution in color and pattern. One woman in Belleville, Pennsylvania, showed the authors a quilt sewn by her grandmother in 1940, a white cotton quilt with a bright blue Dove at the Window pattern. It featured a sawtooth border and finer stitches than one usually sees in contemporary Amish quilts. When questioned why Amish women now use white more freely, she suggested that white was impractical to clean in earlier times; she did not mention the alleged practice of reserving white fabrics for funeral garb. At the bottom of her dower chest she located two quilts finished in 1955; one was a crazy quilt pieced in solid-colored velvet patches, each edged with embroidery stitches and backed with a print flannel. The quilt was exceedingly heavy and was undoubtedly saved just "for show." The second one, completed by the housewife before her marriage, was of yellow cotton dotted with pink and blue tumbling blocks arranged so that they created yellow stars between them. This pattern has been very popular with Ohio families, and it is strong evidence of the influence of outside communities on Amish quilt design.

Letters in the Sugarcreek *Budget* indicate that quilting is not dying out although it may be a dying *art*. A correspondent from New Wilmington, Pennsylvania, advises her readers (May 29, 1975) that "Mrs. John D. Byler says she wants no more quilts until further notice, as she is swamped with quilts and cramped for space." Undoubtedly Mrs. Byler illustrates the trend of the 1970s: more and more Amish women are piecing fancy quilts to sell to the public. These quilts are often indistinguishable from "English" quilts.

Many young Amish girls are not interested in perpetuating the design tradition of Amish quilts; instead, they proudly show visitors the fancy white and purple crepe quilts, embroidered in a spider-web design, which they have tucked away in their dower chests. Perhaps because the young people mix more with outsiders, they are not inclined to spend hours learning the craft of their grandmothers. Older Amish seamstresses regret that young girls cannot use a needle with precision, cannot piece accurately, and lack the patience to bend over an elegant quilt top for long hours.

It is sometimes surprising to discover the Amish attitude toward these quilts, which are currently so prized by the "English." John Kouwenhoven comments in *Made in America* that "we had been successfully taught, by those who we readily agreed were our betters, that what was useful was not beautiful."[59] Thus the Amish, like many nineteenth-century craftsmen and small manufacturers, have been conditioned to view their products—from the bedcover to the plow—as functional but not always special or aesthetically pleasing. Except for the elderly members of the community, who have stronger emotional links with the past, the contemporary Amish prefer modern materials; the women are eager to use the practical synthetics and brilliant embroidery threads and even, if they can rationalize it, a modern electric sewing machine.

John Hostetler, in *Amish Society*, notes with regret the changes in artistic experience and expression that he has observed in recent years.

> Traditional decorative art in homes was usually modest but evident in needlecraft, penmanship, and family records. Designs on chair cushions or on furniture today lack the dignity of their earlier traditional motifs. Antiques are frequently sold. In Amish corner cupboards or on open shelves gayly colored show china from the dime store is mingled with family heirloom pieces a century or more old. The lust of the eye, it would appear, has deceived them in knowing what is traditional and in keeping with their otherwise nonconformed culture.[60]

Amish quilts are eagerly sought today by private collectors, antiques dealers, and art museums for many reasons, not the least being that fine quilts, in the old tradition, are no longer being made. Millen Brand, in a sensitive discussion of the Pennsylvania Germans, remarked that Amish girls, dressed in a spectrum of blues and purples and greens, reminded him "of a shy rainbow."[61] Perhaps it is this fleeting quality of an isolated but changing culture that many collectors are trying to capture through the possession of their Amish quilts.

XI. CONCLUSION:

DIVERSITY WITHIN CONFORMITY

Amish quilts are an honest and intimate reflection of a society to which we do not have easy access. Their strong designs and striking colors, arranged in infinite combinations, allow us a glimpse of the richness, vitality, and diversity of the Amish people, which we cannot perceive simply by driving down a country lane. Our first impression in an Amish community is one of uniformity and conformity; the quilts refute this with their dazzling variety. The stunning bedcovers reproduced on the following pages are powerful, if silent, testimony to those individual talents which have flourished on "plain and simple" Amish farms across the country.

ACKNOWLEDGMENTS

Clara Jean Davis deserves a special acknowledgment for originally suggesting the study and collecting of Amish quilts in Lancaster County, Pennsylvania.

David Luthy of the Amish Historical Library, Maureen Consolantis of the Drexel University Library, and the staff of the Mennonite Historical Library in Goshen, Indiana, have been most helpful in providing background information on Amish culture. Gertrude Huntington and John A. Hostetler, contemporary authorities on the Amish, listened to our theories about the origins of Amish quilting traditions and provided much encouragement.

We are grateful to Madge and Jim Barnett for the information they supplied about Amish seamstresses in Lancaster County.

Also, we wish to give special mention to the splendid photographs of Amish quilts made by Terry McGinniss, New York; Arthur Vitols, Helga Photo Studio, New York; and Thomas Wedell, Cranbrook Academy, Bloomfield Hills, Michigan. Thomas Wedell took the fine black-and-white photographs of the Amish people and places in Lancaster County, and Larry Jordan of Goshen, Indiana, photographed the interior of Spector's Store and the Amish clothes drying in the wind.

We are especially grateful to our editor, Cyril I. Nelson, whose wise counsel and appreciation of fine quilts helped us to do justice to the glorious Amish quilts pictured in this volume.

Naturally, no book of this kind would be possible without the generous and always gracious cooperation of the following collectors and dealers whose taste and enthusiasm are evident in our quilt "gallery." We are grateful to them all.

America Hurrah Antiques, New York; Art Advice Associates, New York; Mr. and Mrs. Edwin Braman; Renee Butler, Potomac, Maryland; Albert Eisenlau Gallery, New York; Mr. and Mrs. Peter Findlay, New York; Evelyn and Hovey Gleason, Marietta, Pennsylvania; Phyllis Haders, New York; Bryce and Donna Hamilton, Tipton, Iowa; Ted Hicks; Timothy and Pamela Hill, South Lyon, Michigan; Jonathan Holstein and Gail van der Hoof; Barbara S. Janos and Barbara Ross, New York; Margot Johnson; Mrs. Jacob M. Kaplan; Kelter-Malcé Antiques, New York; Susan C. Kolker; Ron and Marilyn Kowaleski, Wernersville, Pennsylvania; Jay and Susen Leary, New Holland, Pennsylvania; Sandra Mitchell, Southfield, Michigan; Blanche Robinson; Warren and Jane Rohrer; Patricia and James Rutkowski; George E. Schoellkopf Gallery, New York; Mary Strickler's Quilt Gallery, San Rafael, California; Thos. K. Woodard: American Antiques & Quilts, New York

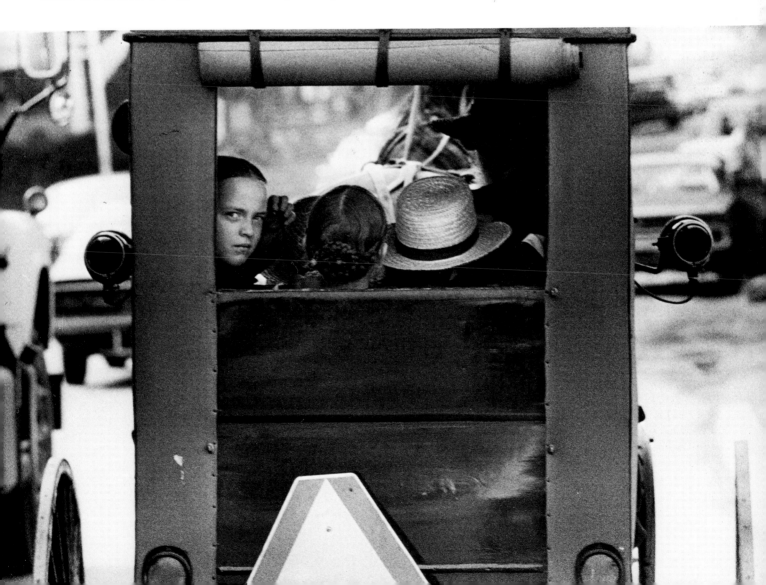

PENNSYLVANIA QUILTS

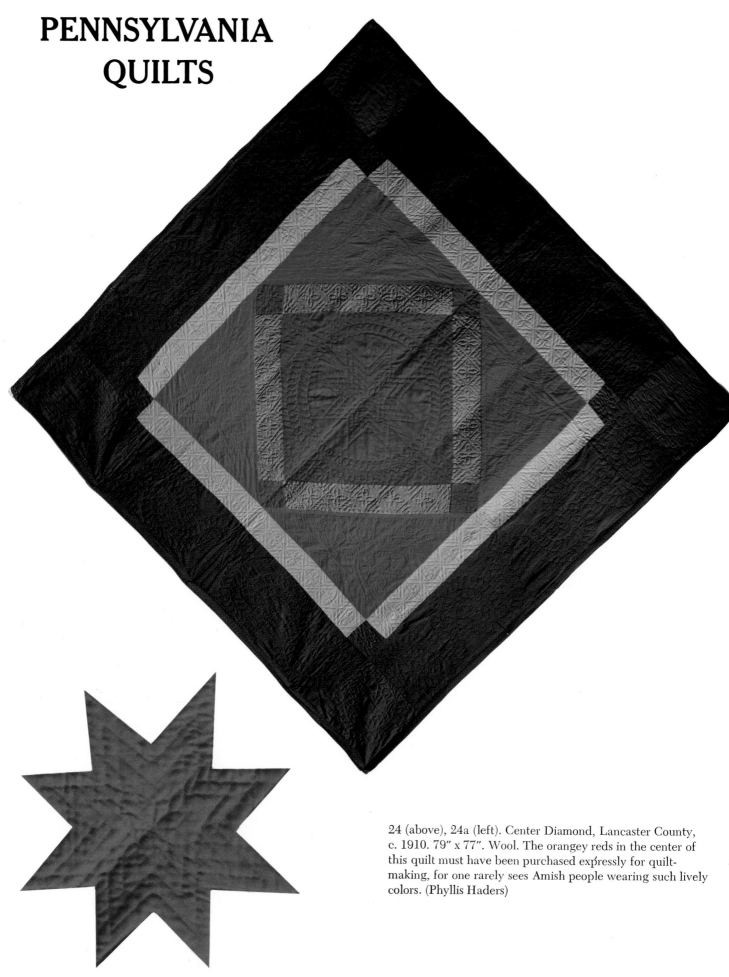

24 (above), 24a (left). Center Diamond, Lancaster County, c. 1910. 79″ x 77″. Wool. The orangey reds in the center of this quilt must have been purchased expressly for quilt-making, for one rarely sees Amish people wearing such lively colors. (Phyllis Haders)

25 (below), 25a (right). Center Diamond, Lancaster County, c. 1900. 85″ x 84″. Wool. Not content with a plain diamond, the creator of this bedcover added triangles of different sizes to form a Center-Diamond-within-a-Center-Diamond. (Jonathan Holstein and Gail van der Hoof)

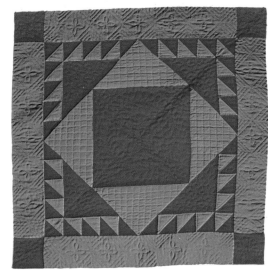

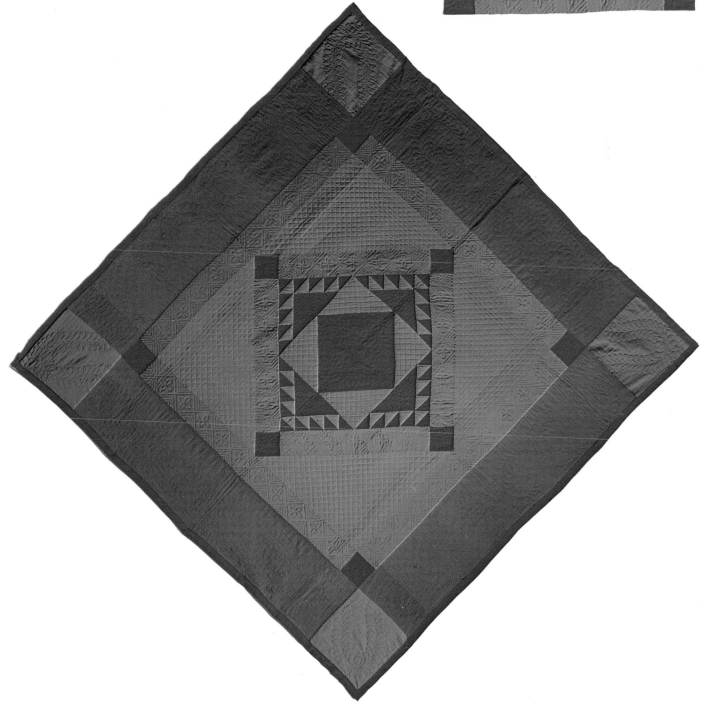

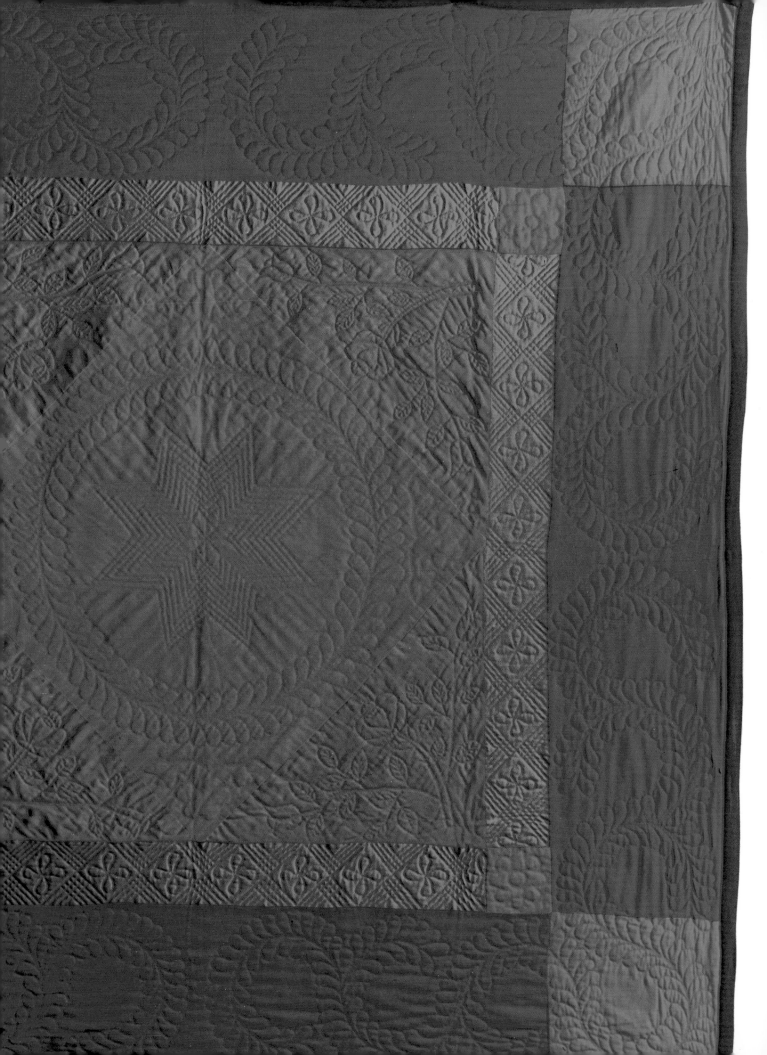

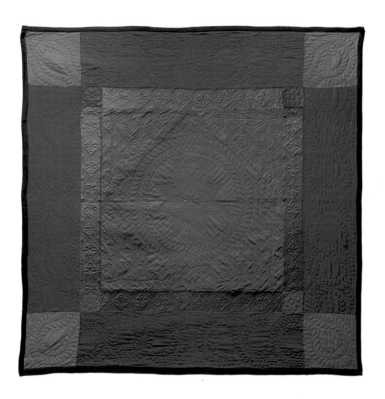

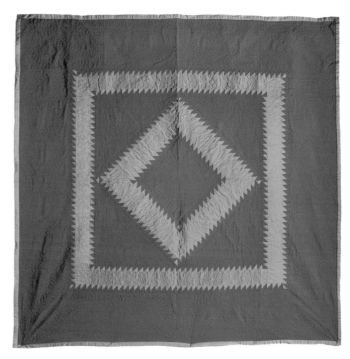

26 (above), 26a (opposite). Center Diamond, Lancaster County, 1915–1925. 80″ x 80″. Wool. The tiny stitches in this classic Lancaster County Amish quilt make the motifs stand out in vivid relief. (Bryce and Donna Hamilton)

27 (above), 27a (below). Sawtooth Diamond, Lancaster County, c. 1920. 83″ x 84″. Wool. This classic Sawtooth design is given added strength with two glowing colors of equal intensity. The inner border and the diamond border are quilted with roses and leaves, not usually found in this location on an Amish quilt. (Mr. and Mrs. Peter Findlay)

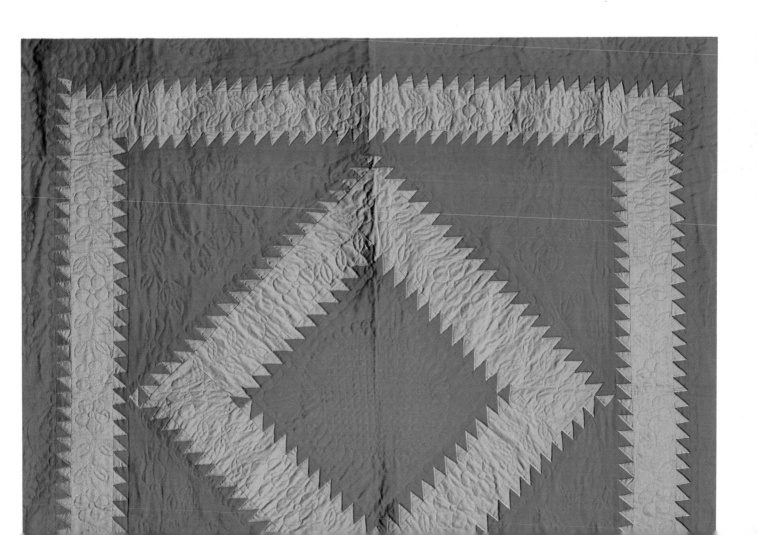

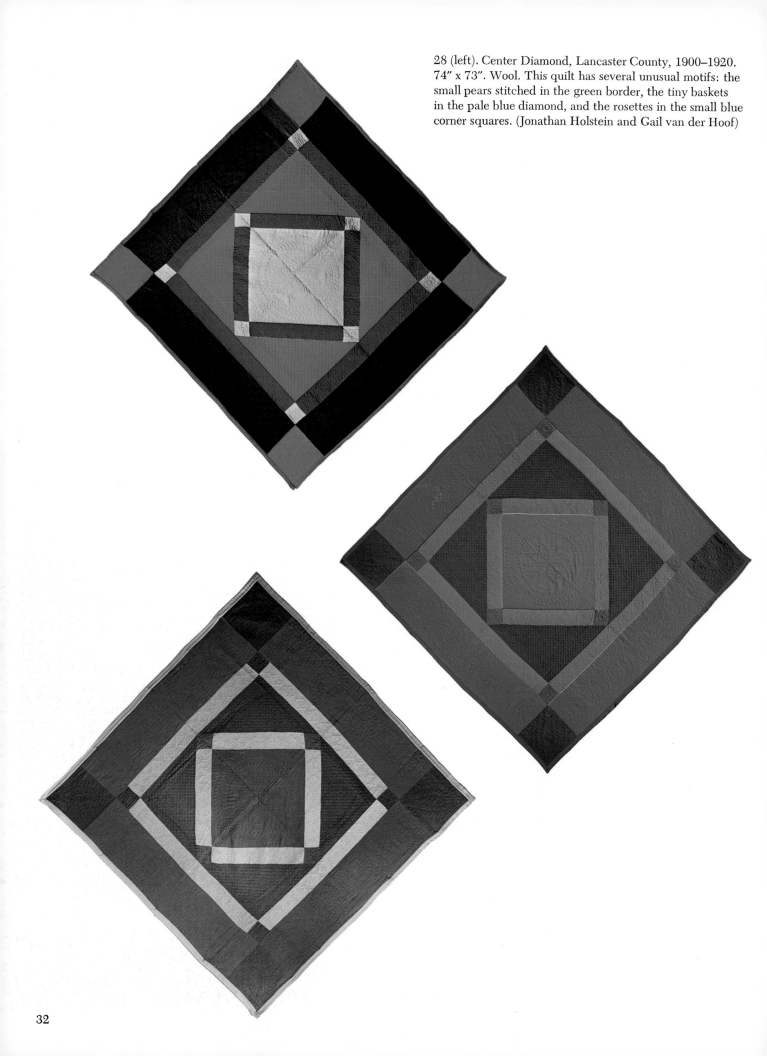

28 (left). Center Diamond, Lancaster County, 1900–1920. 74″ x 73″. Wool. This quilt has several unusual motifs: the small pears stitched in the green border, the tiny baskets in the pale blue diamond, and the rosettes in the small blue corner squares. (Jonathan Holstein and Gail van der Hoof)

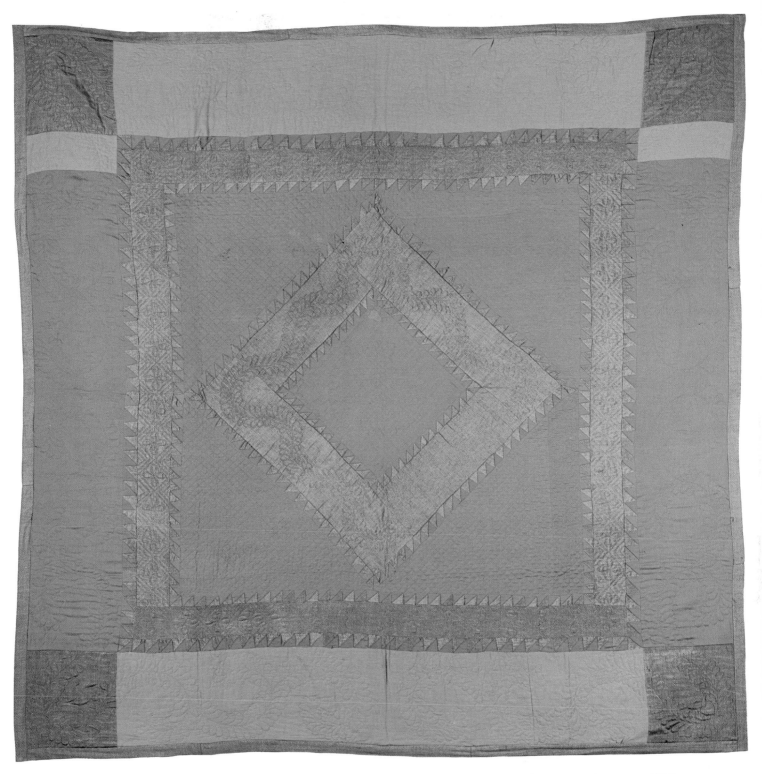

29 (opposite, center). Center Diamond, Lancaster County, c. 1918. 80″ x 80″. Wool. This elegant Amish bishop's "show" quilt has a most unusual red-orange silk backing, which makes a brilliant canvas for a wide range of quilting motifs. (Barbara S. Janos and Barbara Ross)

30 (opposite, below). Center Diamond, Lancaster County, 1915–1925. 78″ x 78″. Wool. The Princess feathers, deeply looped in each corner, are very finely quilted here. Skilled Amish seamstresses often drew these patterns freehand before quilting them. The back of this quilt is shown in a black-and-white photograph (figure 7 on page 6) that highlights the beautiful quilting. (Jonathan Holstein and Gail van der Hoof)

31 (above). Sawtooth Diamond, Lancaster County, c. 1900. 85″ x 87″. Wool. The combination of gray and turquoise blues in this fine wool quilt is not common in Amish bedcovers. The seamstress has placed two brighter turquoise pieces in the right-hand border, either to break up a too-perfect design, or simply because she had used up the darker color. (Jay and Susen Leary)

32, 32a (below). Center Diamond variation, Lancaster County, c. 1925. 80″ x 80″. Wool. Several features make this superb quilt a rare one: it is composed of lighter colors rather than bright or somber ones, and its center diamond is embellished with a tulip appliqué, almost never seen in Amish quilts. Perhaps this Amish seamstress saw an appliqué quilt at a farm sale and decided to imitate the technique on a limited scale. (Bryce and Donna Hamilton)

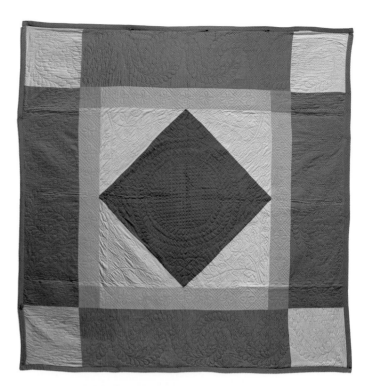

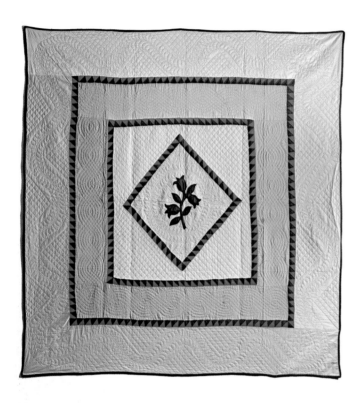

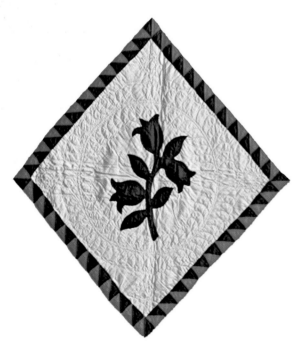

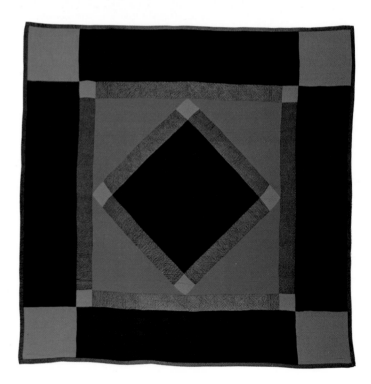

33 (top). Center Diamond, Lancaster County, 1920–1930. 76″ x 74″. Wool. The rose motifs in the pale gray triangles suggest that this quilt was made after 1920, as does its flannel backing. (Jonathan Holstein and Gail van der Hoof)

34 (bottom). Center Diamond, Lancaster County, c. 1900. 75″ x 75″. Wool. The small red corner squares are more vivid than the triangles, and they are not exactly even, so that the diamond itself seems to curve. The rich, dark brown color of the wide borders is unusual in Amish quilts. (Ted Hicks)

35 (below). Center Diamond, Lancaster County, c. 1900.
77″ x 76″. Cotton and wool. The electric red diamond
contrasts powerfully with the predominantly quiet colors of
this quilt. (Ted Hicks)

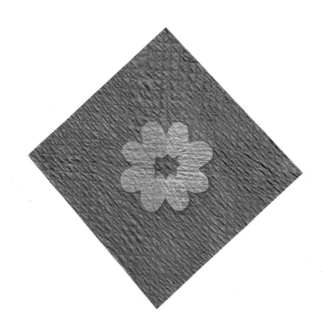

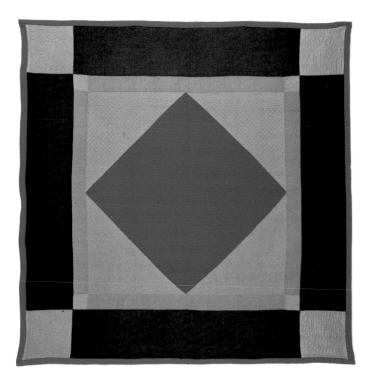

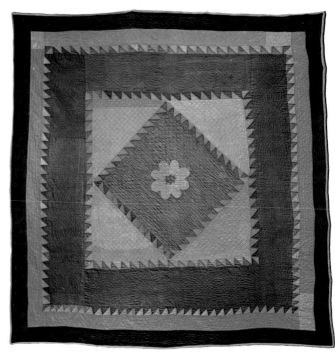

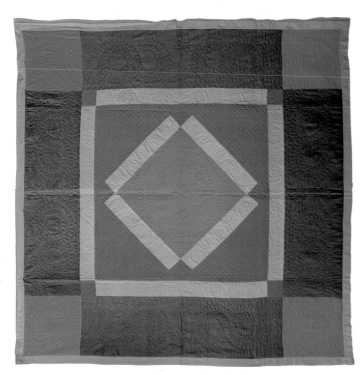

36 (left). Center Diamond, Lancaster County, c. 1930.
76″ x 75″. Cotton and wool. Although this is a more recent
quilt, the artist has still used traditional designs and
materials to produce a beautiful bedcover. (Jonathan Holstein
and Gail van der Hoof)

37, 37a (above). Sawtooth Diamond, Lancaster County,
c. 1920. 82″ x 79″. Cotton. The most unusual feature of this
carefully pieced bedcover is the appliquéd flower in the
center. Appliquéing is almost never seen on Amish quilts
because it is considered a frivolous practice, providing
decoration but not additional warmth.

38 (right). Sawtooth Diamond, Lancaster County, c. 1890. 82″ x 84″. Wool. The subtle colors of this quilt are arranged for maximum contrast. Note the variation in gray and pink strips in the narrow, inner, sawtooth border. (Jay and Susen Leary)

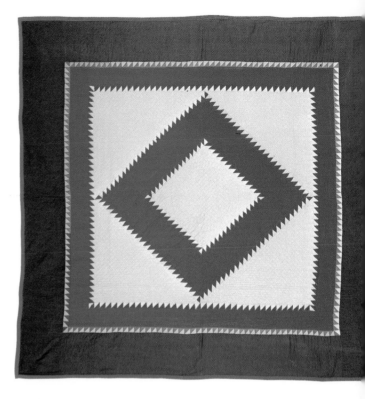

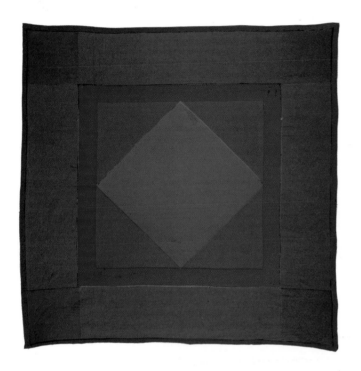

39 (left). Center Diamond, Lancaster County, c. 1920. 84″ x 84″. Cotton and wool. Tulips are placed at the ends of the Quaker feathers, which are coiled around the wide borders of this brilliant quilt. (Ted Hicks)

40 (below). Center Diamond, Lancaster County, 1910–1920. 79″ x 80″. Wool. The absence of corner squares makes the center diamond all the more powerful; the red triangles are particularly vibrant and draw the observer's eye to the center of the quilt. (Ted Hicks)

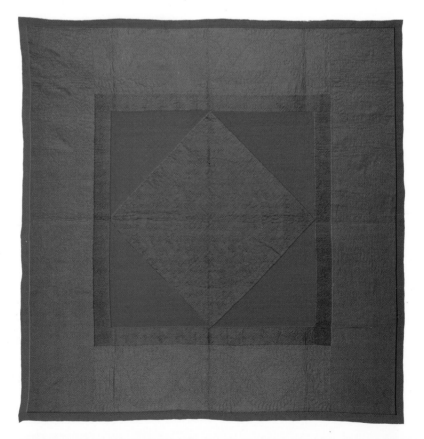

41 (right). Center Diamond, Lancaster County, 1900–1910.
77" x 76". Wool. As happens with many Amish quilts,
a color that appears in one part of the quilt takes on a different
character when it appears in another part of the quilt.
Thus the red in the inner border, set against the palest
mauve, seems more brilliant than the rich red of the wide
border. (Ted Hicks)

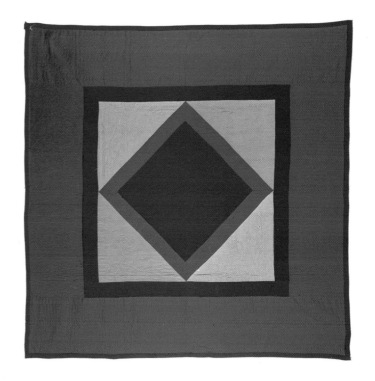

42 (below). Sawtooth Diamond, Lancaster County, 1880–
1900. 85" x 83". Wool. The red triangles and borders have
retained their brilliance in this quilt, while the indigo
green faded, as it commonly did. The outstanding feature of
this quilt is the superb, elaborate stitching; the seamstress
took a common motif—the wreath—and personalized it
with tiny stitches and unusual placement. (Jonathan Holstein
and Gail van der Hoof)

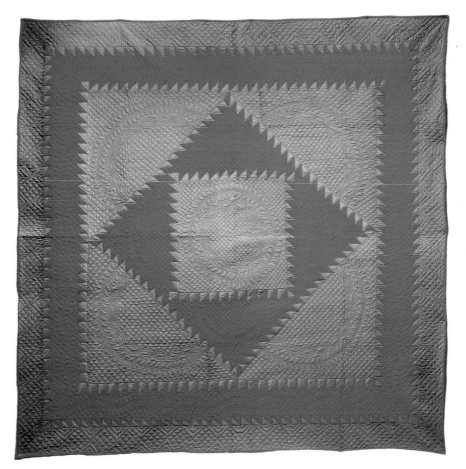

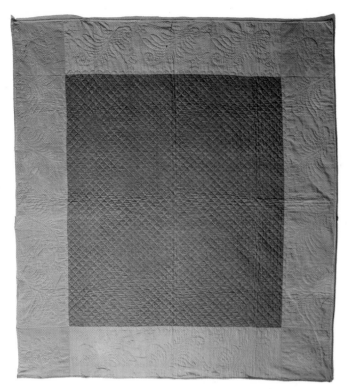

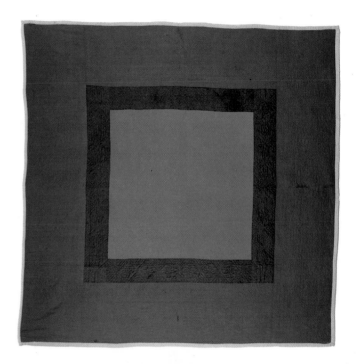

44 (below). Center Square, Lancaster County, 1875–1900. 81″ x 81″. Wool. This classic format of a frame-within-a-frame is enlivened by the bold green inner border stitched with "pumpkin-seed flower" motifs. (Warren and Jane Rohrer)

43 (above). Center Square, Lancaster County, 1860–1870. 81″ x 74″. Wool. The simple design of this rare quilt suggests that the earliest Amish quilts were quite plain, composed of a few pieces of fabric but with intricate stitching. The wide brown borders are embellished with fiddlehead fern motifs and the corners bear simple wreaths with a starflower in their centers. (Jonathan Holstein and Gail van der Hoof)

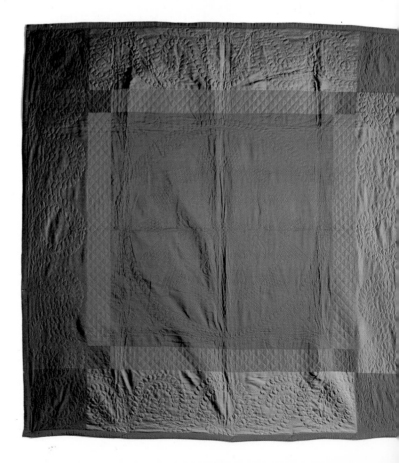

45 (right). Center Square, Lancaster County, c. 1890. 78″ x 78″. Wool. This favorite Amish format is deceptively simple, for fine quilting covers every inch of its surface. Note especially the sun that encircles the unusual stitched Easter lilies in the center of the quilt. (Mr. and Mrs. Peter Findlay)

46 (opposite, above). Unnamed design, Pennsylvania, 1890–1900. 82″ x 81″. Wool. The overall designs of the two quilts on this page are so similar, and so rare among the Amish, that one might imagine that they were made by the same family. (Mr. and Mrs. Edwin Braman)

47 (opposite, below). Unnamed design, Pennsylvania, c. 1900. 78″ x 80″. Wool. Although the geometric checkerboard design is elegant and sophisticated, this quilt incorporates many small patches of different colors and thus is an excellent example of the "salvage art." Note the unusual shell stitching in the outer border. (Mr. and Mrs. Peter Findlay)

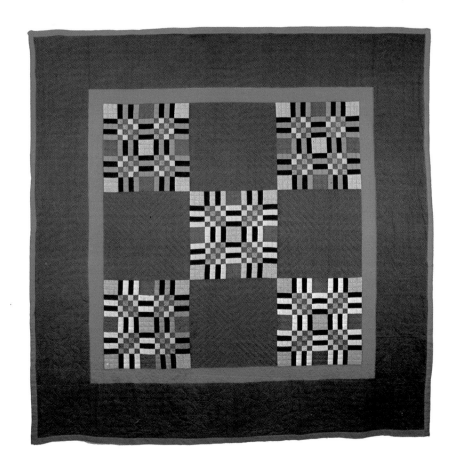

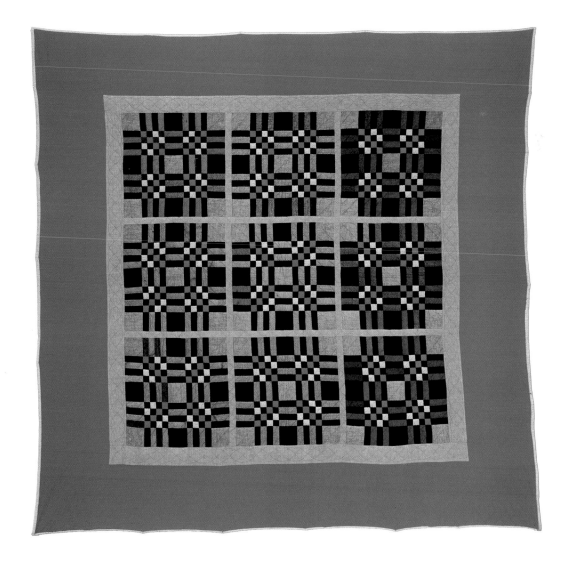

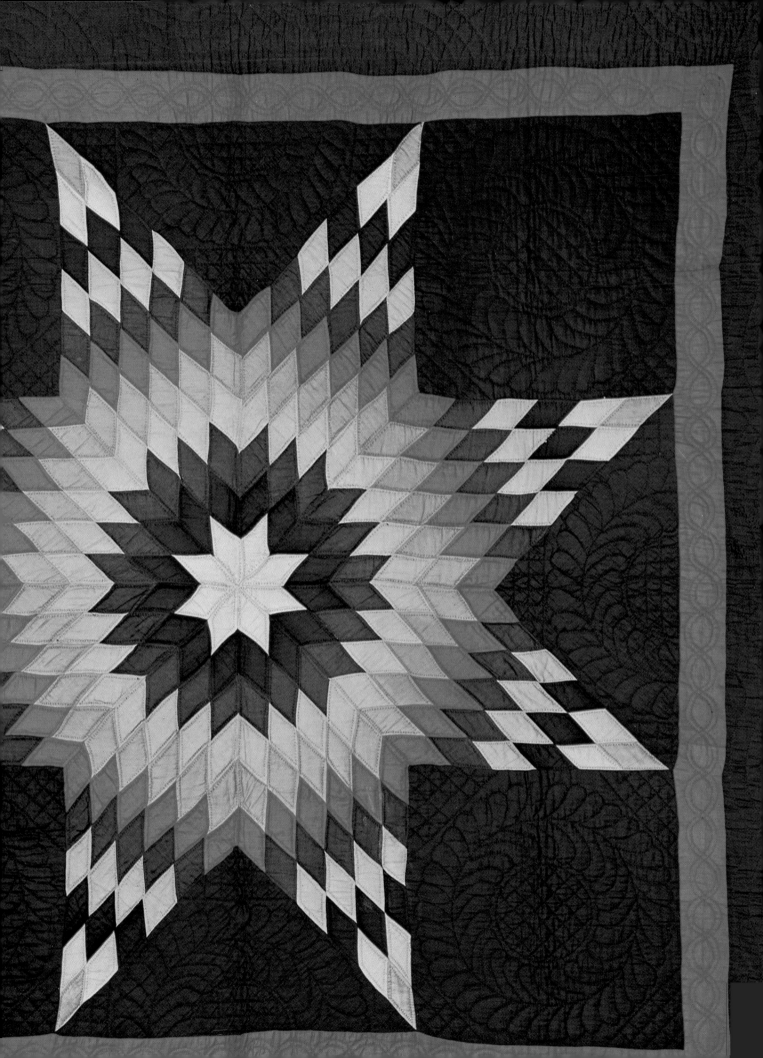

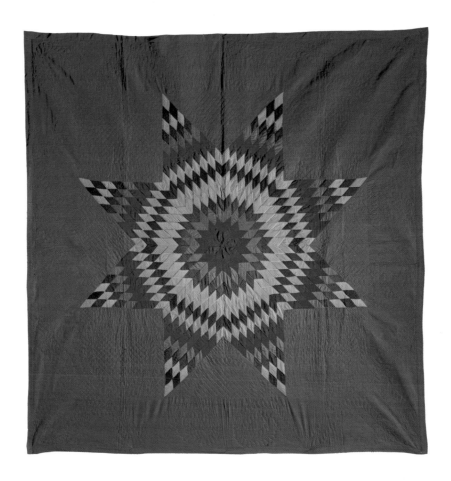

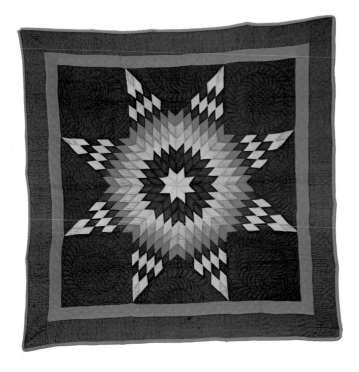

48 (above). Lone Star, Lancaster County, 1910–1930. 80″ x 80″. Cotton. This is a powerful quilt because the sky-blue field is not cluttered with smaller stars or with corner squares. (Mr. and Mrs. Peter Findlay)

49 (left), 49a (opposite). Star of Bethlehem. Lancaster County, c. 1910. Wool. The judicious arrangement of diamonds that compose this quilt gives the star a pulsating quality. (George E. Schoellkopf Gallery)

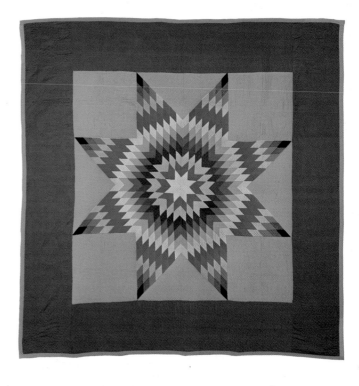

50 (right). Star of Bethlehem, Lancaster County, 1930–1940. 91″ x 89″. Cotton and wool. This brilliant star in a field of blue is defined by the black diamonds at the tip of each point and is effectively framed with the contrasting purple border. (Jay and Susen Leary)

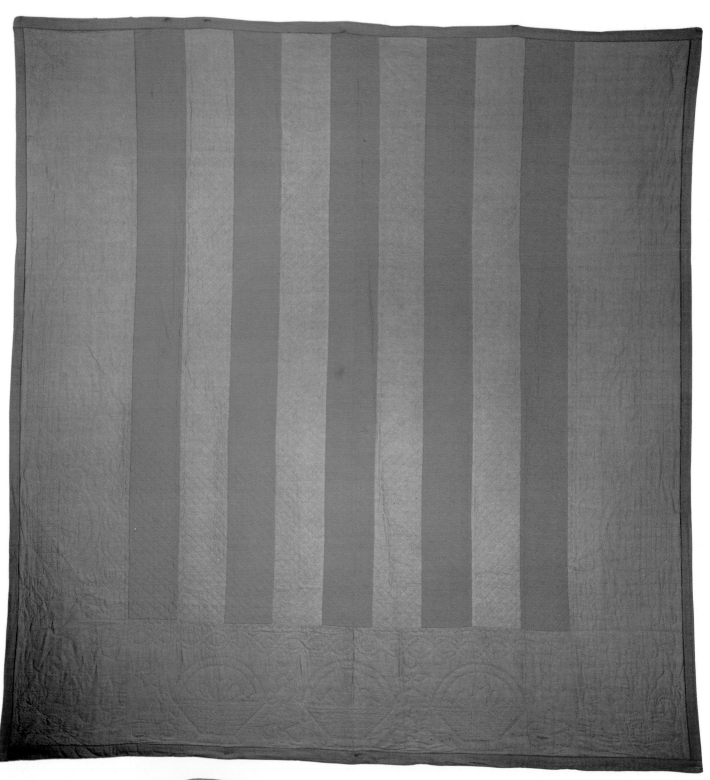

51 (above), 51a (left). Bars, Lancaster County, 1880–1890. 79″ x 74¼″. Wool. Unlike most Amish Bars quilts, the bars run all the way to the end on one side, indicating perhaps the head of the bed. (Mrs. Jacob M. Kaplan)

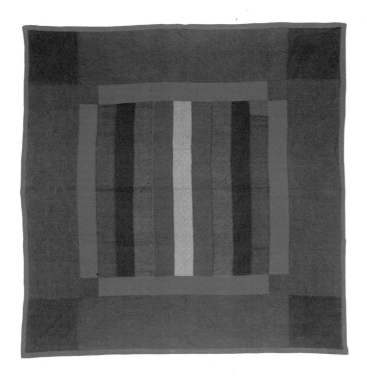

52 (left). Bars, Lancaster County, 1900–1910. 80″ x 81″. Wool. The glowing silvery-gray stripe in the center of this quilt is the focal point of the unusual row of bars of several colors. (Thos. K. Woodard: American Antiques & Quilts)

53 (below). Bars, Lancaster County, c. 1890. 78″ x 78″. Wool. This is a classic Bars quilt, with glowing gray wool substituted for white to avoid a patriotic red, white, and blue combination. (Phyllis Haders)

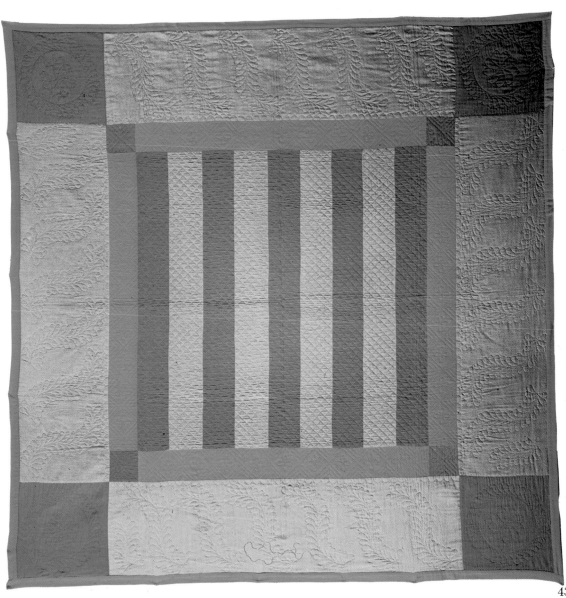

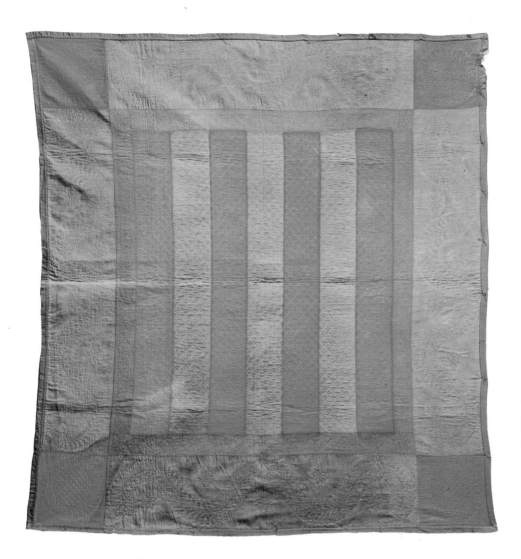

54 (left). Bars, Lancaster County, 1860–1870. 78" x 72". Wool. In this very early Amish quilt the wool has taken on a soft silken quality. The tiny stars and the finely gridded wreaths in the corner squares appear most frequently in the oldest Amish quilts. The "indigo green" color of the bars and borders has faded to the point that one can see its original components, indigo blue and yellow. (Jonathan Holstein and Gail van der Hoof)

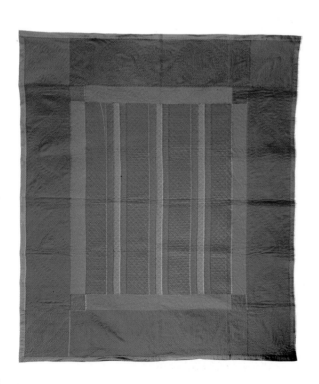

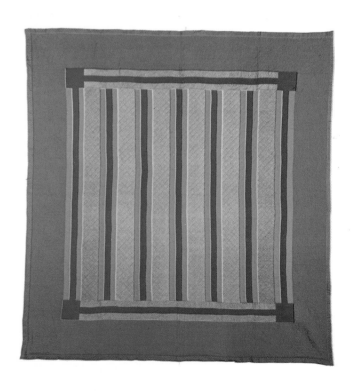

55 (opposite, below left). Split Bars, Lancaster County, 1900–1920. 88″ x 76″. Tulips decorate the double-looped feathers that wind around the purple borders of this handsome bedcover. (America Hurrah Antiques, N.Y.C.)

56 (opposite, below right). Split Bars, Lancaster County, c. 1920. 77″ x 72″. Cotton and wool. Fancy Bar variations like this one tend to appear later than the simple, uncluttered, "floating" Bars quilts that were more common in the late nineteenth century. Finely quilted grapes and grape leaves wind up and down the split bars. (Jay and Susen Leary)

57 (right). Back, Bars quilt, Lancaster County, 1900–1910. 74″ x 62″. Wool. It is rare to find the *back* of an Amish quilt pieced so carefully and so symmetrically as this one. One can easily see here the fish-scale pyramids and the flowers composed of heart-shaped petals that are stitched around the borders of the quilt. This is the back of the quilt shown below in figure 58. (America Hurrah Antiques, N.Y.C.)

58 (below). Bars, Lancaster County, 1900–1910. 74″ x 62″. Wool. The pieced stripes that compose this Bars quilt are representative of the brilliant bolts of solid-hued cloth that one can find in dry-goods stores that cater to the Amish (America Hurrah Antiques, N.Y.C.)

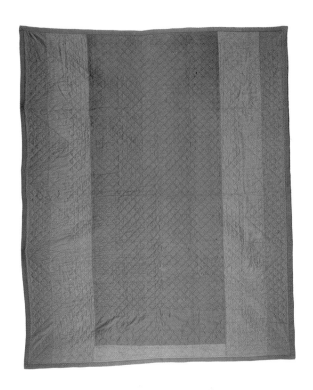

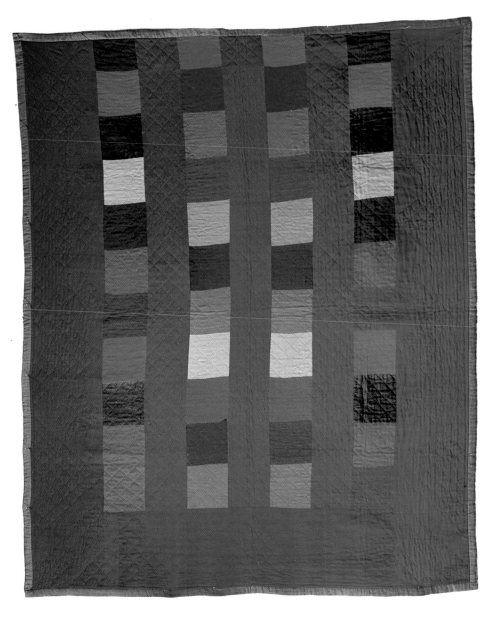

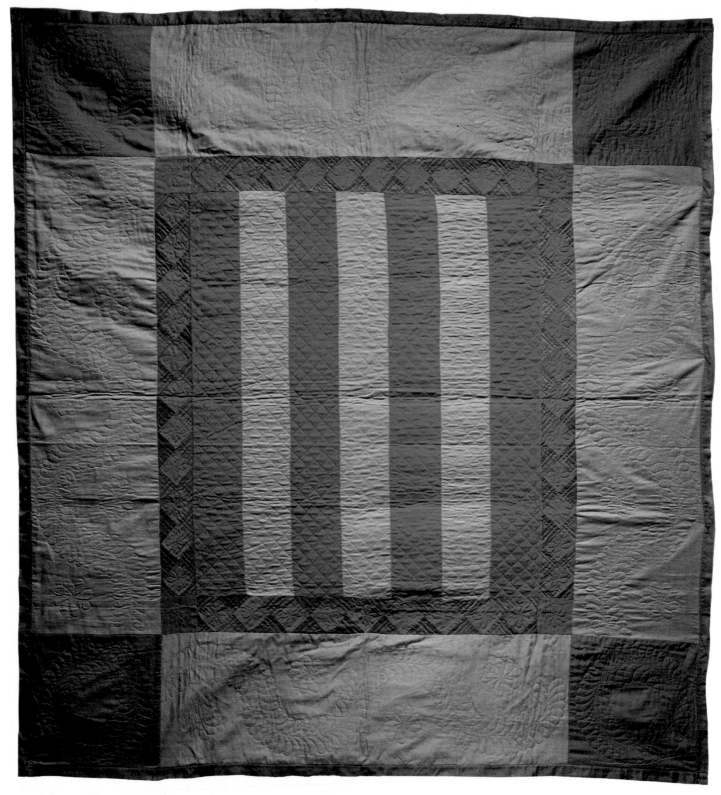

59 (above). Bars, Lancaster County, c. 1920. 86″ x 81″. Wool. The handsome, somber tones of this quilt are set off by the contrasting columns of magenta diamonds in the green inner border. Note the fine waffle stitching across the bars and the Princess feathers and flowers in the wide borders. (Phyllis Haders)

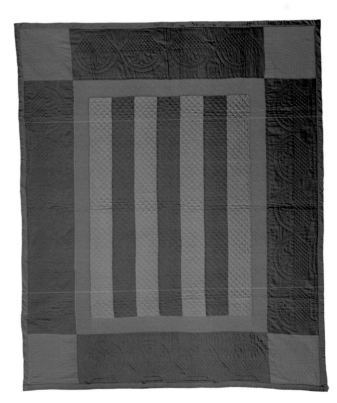

60 (above, left). Bars, Lancaster County, c. 1900. 75″ x 69″. Wool. This bedcover features an unusual range of stitched motifs, from stars in wreaths in the corners to the pineapples in the gray borders and tulips in the bars. The fine wool challis used in this quilt has acquired a mellow sheen. (Warren and Jane Rohrer)

61 (above, right). Bars, Lancaster County, c. 1875. 73″ x 71″. Wool. This heavy wool quilt was made by an Amish woman in Gordonville, Pennsylvania, and kept in her family for 100 years. She has skillfully pieced the red material so that the bars appear to be constructed of solid strips of cloth. The fancy quilted baskets in the green borders contain stitched hearts. (Carl and Elizabeth Safanda)

62 (right). Bars, Lancaster County, 1920–1925. 83″ x 73″. Wool. The stitched baskets in the border, each containing a large tulip, are especially prominent in this beautiful quilt. (Jonathan Holstein and Gail van der Hoof)

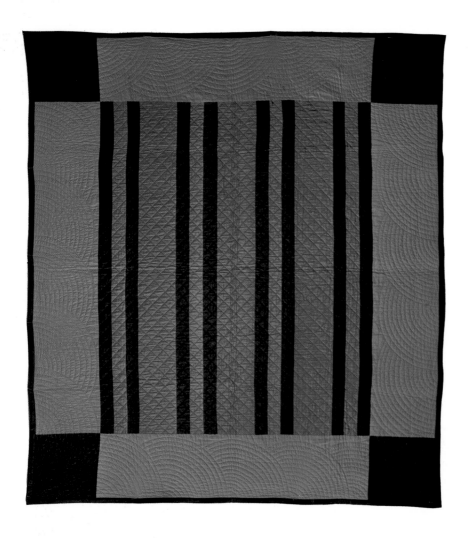

63 (left). Split Bars, Lancaster County, 1920–1930. 76″ x 68″. Cotton. This quilt is a fascinating marriage of the typical Lancaster County format—in this case a variation of the Bars design—and Ohio Amish materials and motifs. The quiltmaker supposedly moved back to Lancaster County from Ohio before she made the quilt, which explains the Midwestern colors and stitching details. (Jonathan Holstein and Gail van der Hoof)

64 (right). Bars variation, Lancaster County, c. 1915. 79″ x 80″. Wool. The cable quilting on the blue bars and the nine-patches in the green bars are the unususal features of this quilt. (Evelyn and Hovey Gleason)

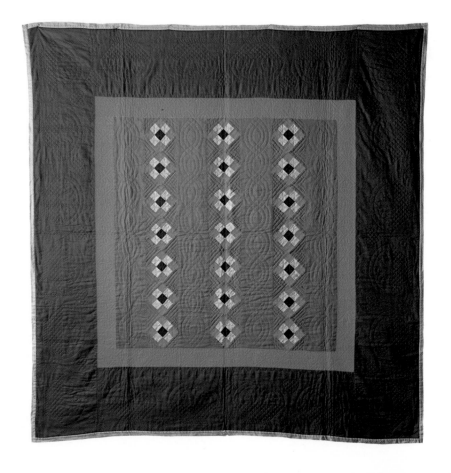

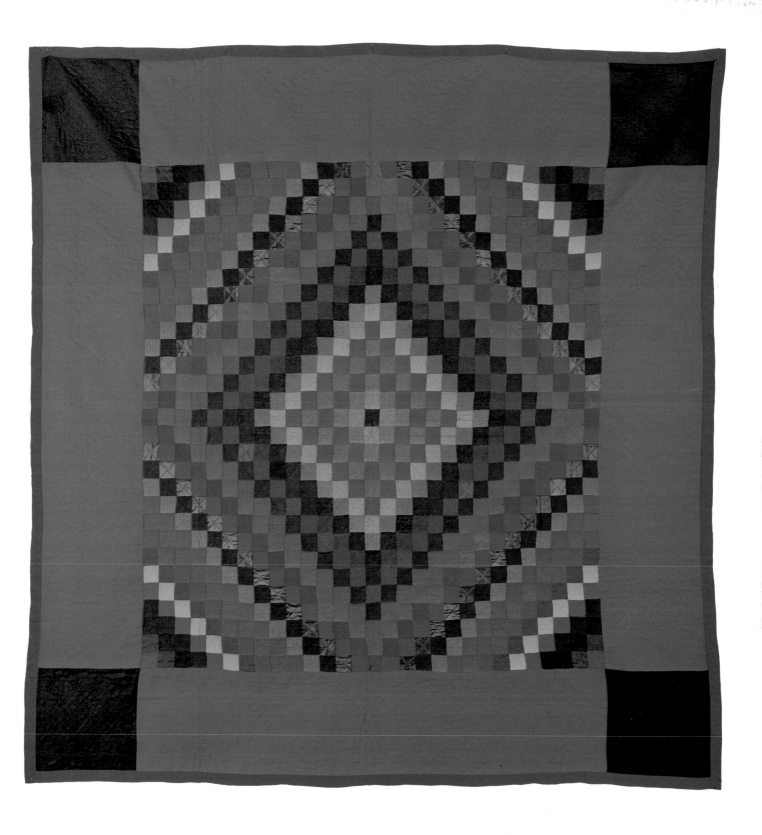

65 (above). Sunshine and Shadow, Pennsylvania, 1900–1925. 76″ x 78″. Wool. This quilt incorporates some striped blue fabric in one wave of diamonds near the outer border. Amish quilts rarely contain patterned fabric except in the backing. (Mr. and Mrs. Peter Findlay)

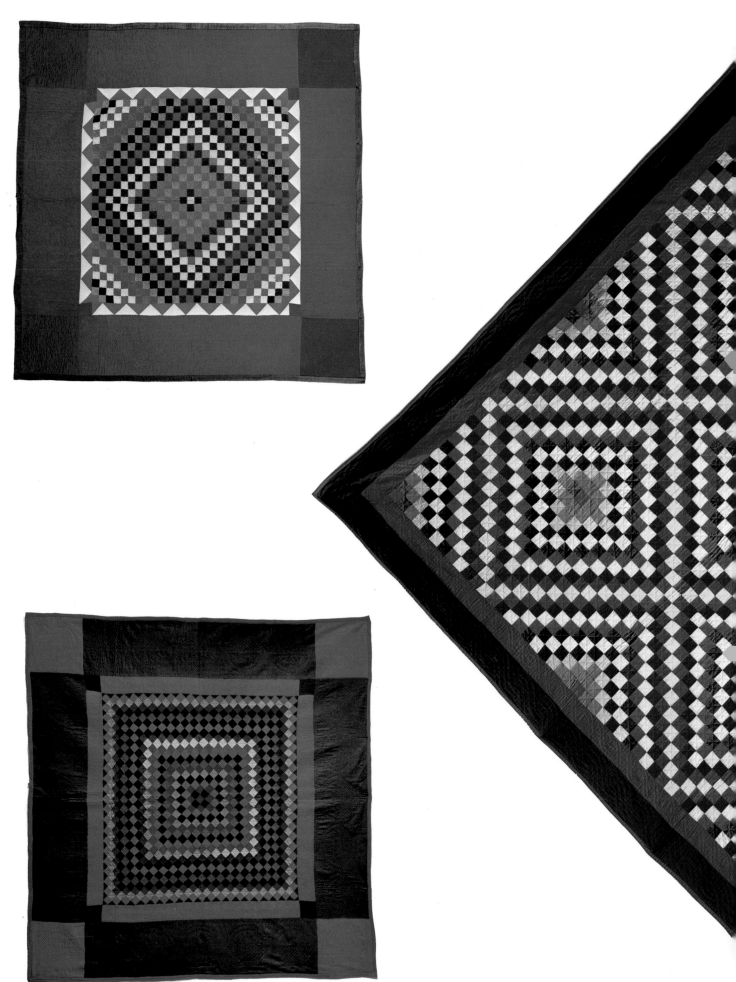

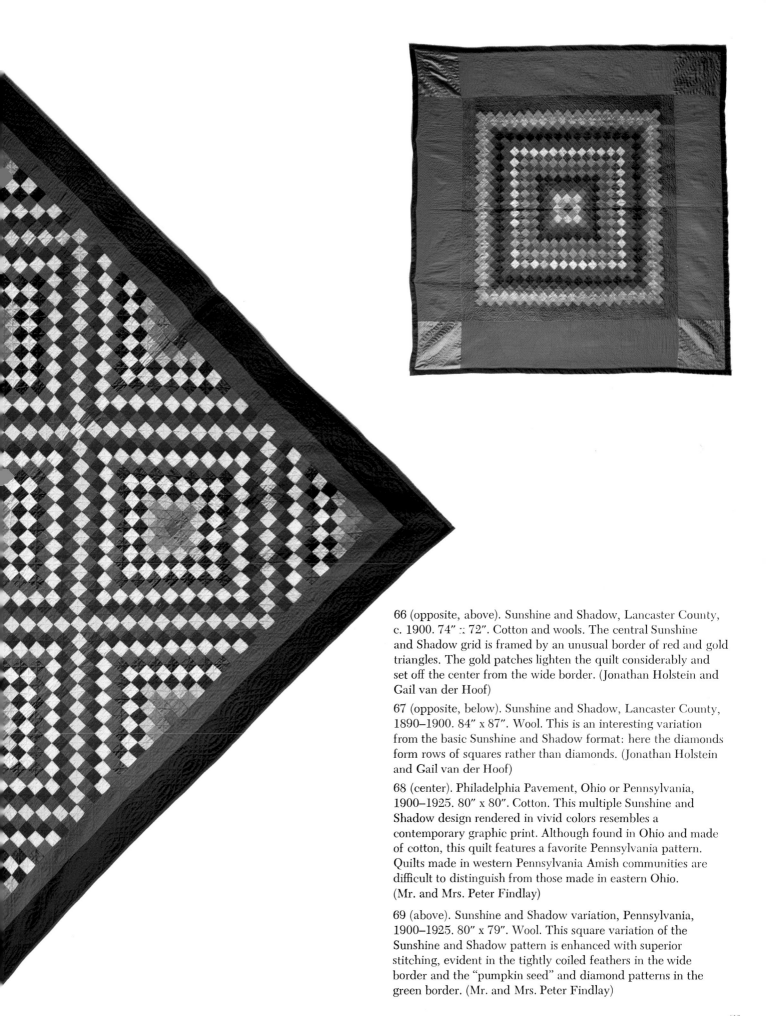

66 (opposite, above). Sunshine and Shadow, Lancaster County, c. 1900. 74″ :: 72″. Cotton and wools. The central Sunshine and Shadow grid is framed by an unusual border of red and gold triangles. The gold patches lighten the quilt considerably and set off the center from the wide border. (Jonathan Holstein and Gail van der Hoof)

67 (opposite, below). Sunshine and Shadow, Lancaster County, 1890–1900. 84″ x 87″. Wool. This is an interesting variation from the basic Sunshine and Shadow format: here the diamonds form rows of squares rather than diamonds. (Jonathan Holstein and Gail van der Hoof)

68 (center). Philadelphia Pavement, Ohio or Pennsylvania, 1900–1925. 80″ x 80″. Cotton. This multiple Sunshine and Shadow design rendered in vivid colors resembles a contemporary graphic print. Although found in Ohio and made of cotton, this quilt features a favorite Pennsylvania pattern. Quilts made in western Pennsylvania Amish communities are difficult to distinguish from those made in eastern Ohio. (Mr. and Mrs. Peter Findlay)

69 (above). Sunshine and Shadow variation, Pennsylvania, 1900–1925. 80″ x 79″. Wool. This square variation of the Sunshine and Shadow pattern is enhanced with superior stitching, evident in the tightly coiled feathers in the wide border and the "pumpkin seed" and diamond patterns in the green border. (Mr. and Mrs. Peter Findlay)

70 (below). Sunshine and Shadow, Lancaster County, 1910–1920. 78″ x 77″. Wool. This is the simplest of the Sunshine and Shadow formats, with no corner squares or inner borders. The palette, too, is rather unusual, incorporating browns and blues to give the quilt a subdued feeling; most Sunshine and Shadow designs use more primary colors or pastel shades. (Carl and Elizabeth Safanda)

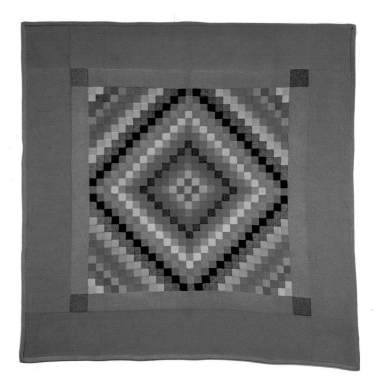

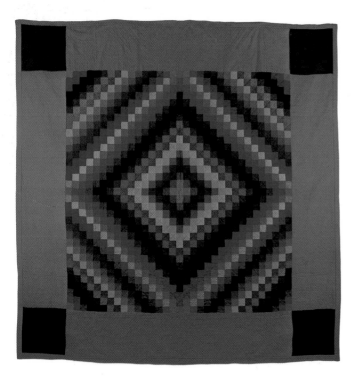

71 (left). Sunshine and Shadow, Lancaster County, 1920–1930. Wool. The shimmering, almost psychedelic tones of the diamonds that radiate from the center of this quilt are suggestive of the 1920s, as is the crepe material used on the face of the quilt. (Mary Strickler's Quilt Gallery)

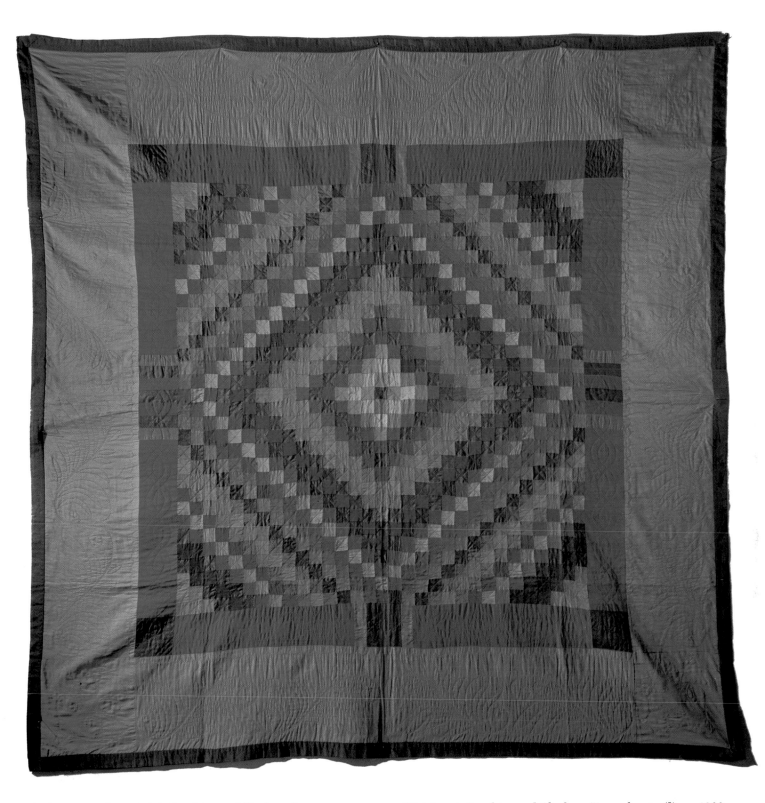

72 (opposite, above right). Sunshine and Shadow, Lancaster County, 1910–1920. 77″ x 78″. A classic rendition of the favorite Sunshine and Shadow design, this quilt is constructed of cotton, some wool patches, and a few taffeta squares. (Ted Hicks)

73 (opposite, below right). Sunshine and Shadow, Lancaster County, 1915–1925. 84″ x 84″. Wool. The colors in this quilt are carefully limited to the cooler side of the spectrum, with no yellows, oranges, or rusty browns. The arrangement of patches from the black wave through the blues gives the effect of transparency and depth. (Ted Hicks)

74 (above). Sunshine and Shadow, Pennsylvania (?), c. 1900. 82″ x 82″. Wool. Although found in Indiana, this stunning version of the Sunshine and Shadow design was probably made in Lancaster County. The wide border contains carefully stitched fiddlehead fern motifs. An unusual touch is the rows of tiny stripes in the red inner border. (Phyllis Haders)

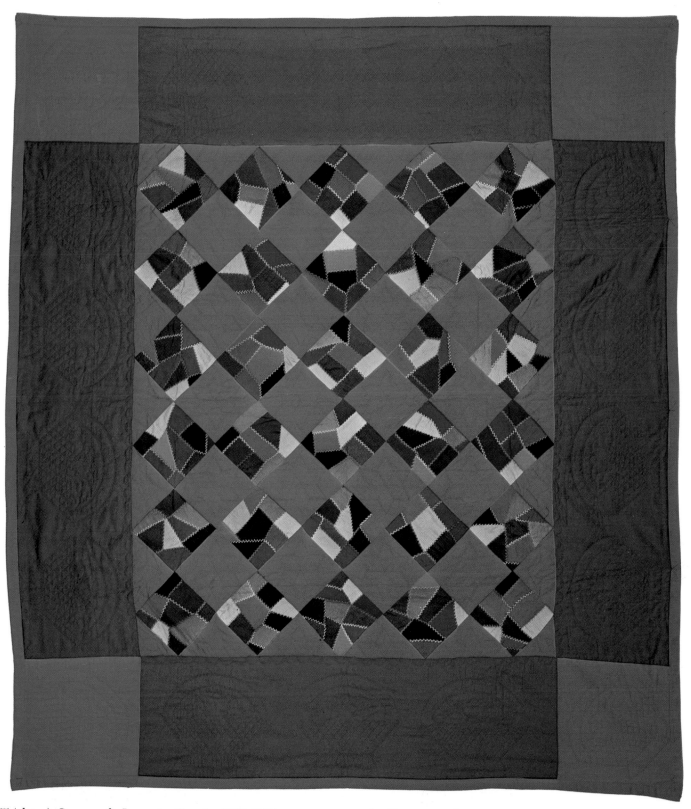

75 (above). Crazy quilt, Lancaster County, 1920–1930. 78″ x 70″. Wool. Relying on strong primary colors, the creator of this quilt has alternated diamonds of red wool with diamonds composed of "crazy" patches. Each patch is outlined with cross-stitches in a contrasting color, a technique often seen in Amish crazy quilts after 1920. (Renee Butler)

76 (opposite, above). Crazy quilt, Pennsylvania or Ohio, 1880–1890. 76″ x 72″. Cotton, wool, silk, and satin. The elegant choice of subdued colors and the stunning arrangement of crazy patches within the diamonds makes the creator of this quilt a true artist. This quilt illustrates

the "fascinating deviations from the norm" that we describe in the text, for it is a beautiful example of the marriage of Amish sensibilities with Victorian taste. (The Metropoltan Museum of Art)

77 (opposite, below). Crazy quilt, Lancaster County, c. 1920. 69″ x 70″. This brilliant composition, resembling an aerial land map, contains patches of cotton, wool, felt, and upholstery remnants with a rough, ribbed texture. One woman in Lancaster County made three quilts (including this one) for her three daughters, and placed a different color heart patch in each quilt. (Carl and Elizabeth Safanda)

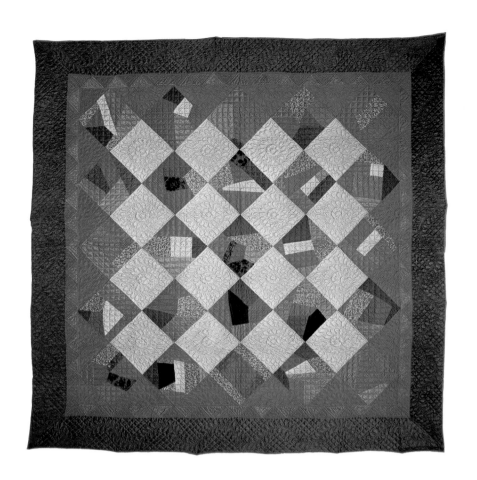

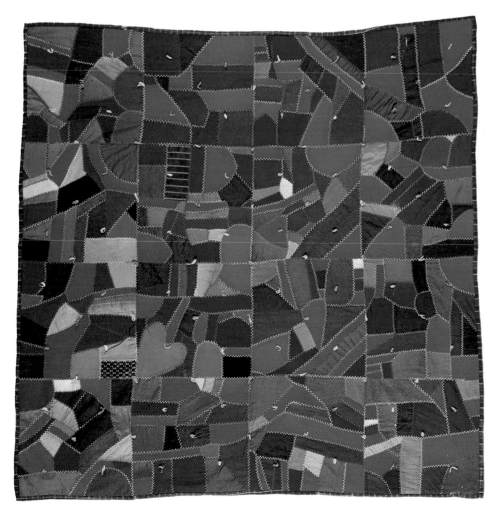

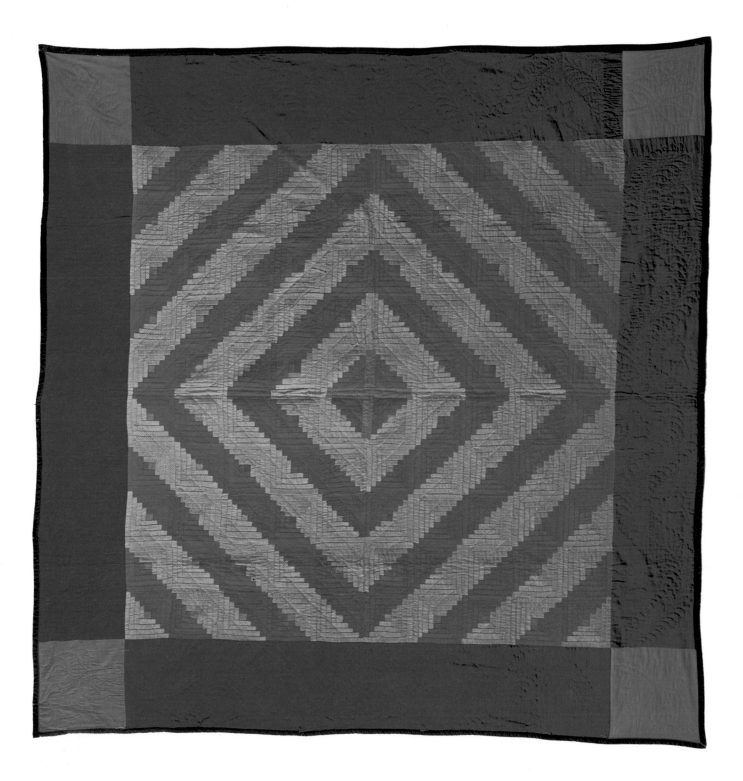

78 (above). Log Cabin, Barn Raising pattern, Lancaster County, 1875–1900. 80″ x 82″. Wool. This rich variation of the Log Cabin design has primitive tulips stitched in the blue borders and coxcomblike flowers in each corner square. (Jonathan Holstein and Gail van der Hoof)

79 (opposite). Windmill Blades, Pennsylvania, 1860–1880. 78½″ x 65″. Wool. This quilt can be dated by the use of home-dyed cloth in mellow tones, by the red homespun filling, and by the flowered chintz backing. (Mr. and Mrs. Peter Findlay)

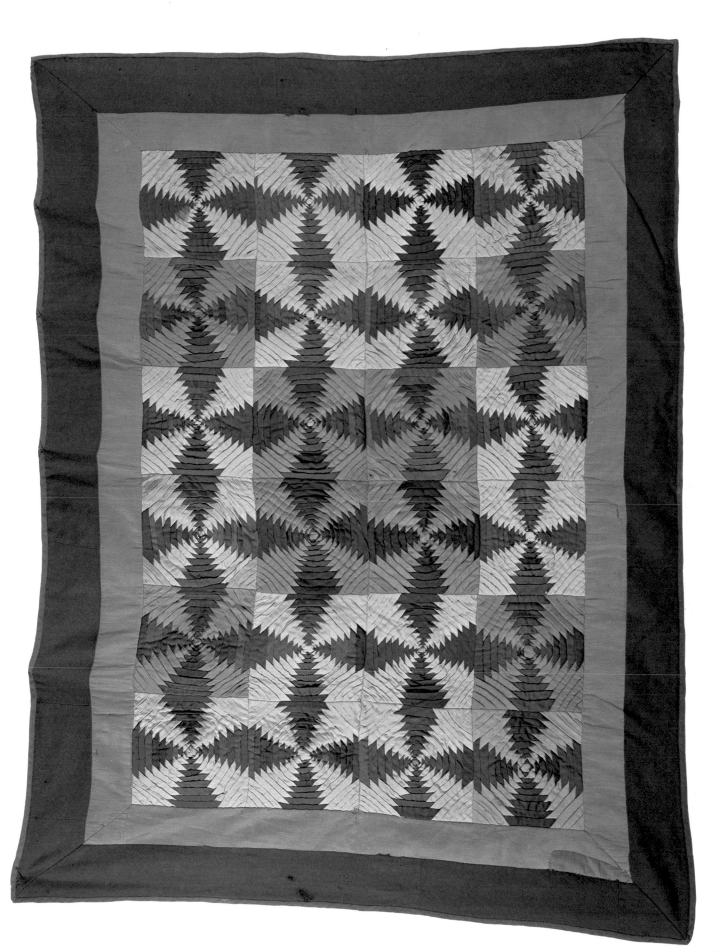

57

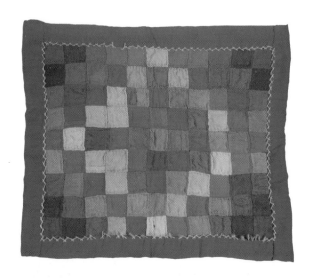

80 (left). One-Patch doll's quilt, Lancaster County, 1900–1925. 11″ x 13″. Wool. This quilt resembles a primitive Sunshine and Shadow design, with coordinated waves of color—reds, then greens, then brown tones. Dolls' quilts are rarely found, for the Amish would generally consider them to be frivolous and impractical. (Ron and Marilyn Kowaleski)

81 (below). Double Pinwheel, Lancaster County, 1875–1900. 78″ x 76″. Wool. This lovely, haunting quilt deviates from the traditional Lancaster County quilt on several counts: it has fiddlehead ferns stitched in the wide borders rather than the more typical Princess or Quaker feather. The Nine-Patches in the center of the quilt are altered to form pinwheels. Because the small pinwheels are integral parts of the triangles of the larger pinwheels, there is a great deal of circular movement in the quilt. (Jonathan Holstein and Gail van der Hoof)

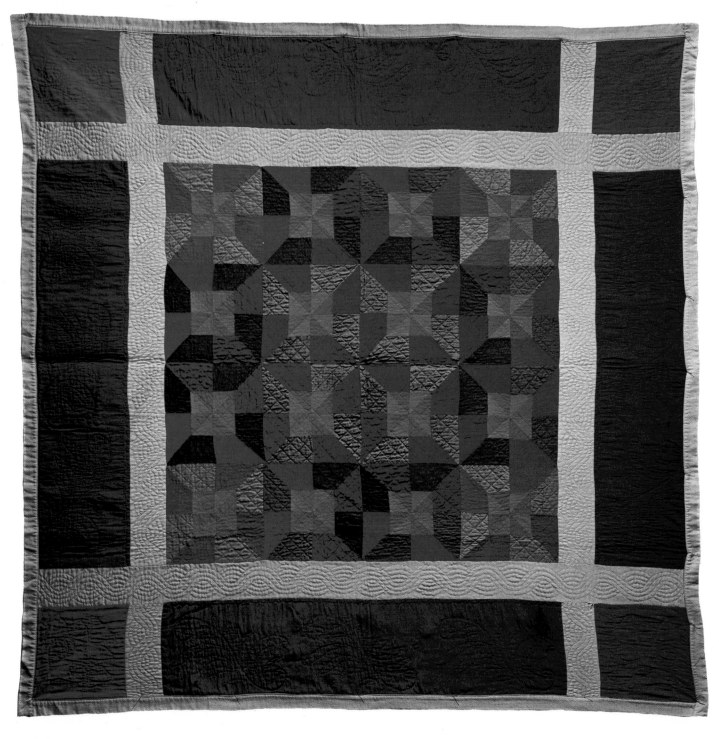

82 (right). Fans, Pennsylvania, 1900–1925. 75" x 88". Wool. The elaborate scroll stitching in the gray outer border resembles closely the blind-tooled decorations often found in nineteenth-century *Ausbunds*, the Amish hymnals. (Mr. and Mrs. Peter Findlay)

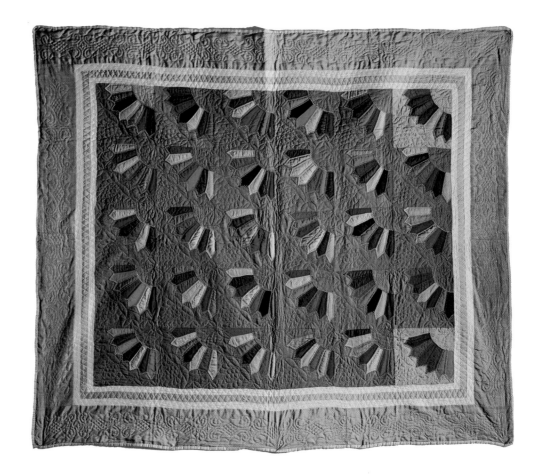

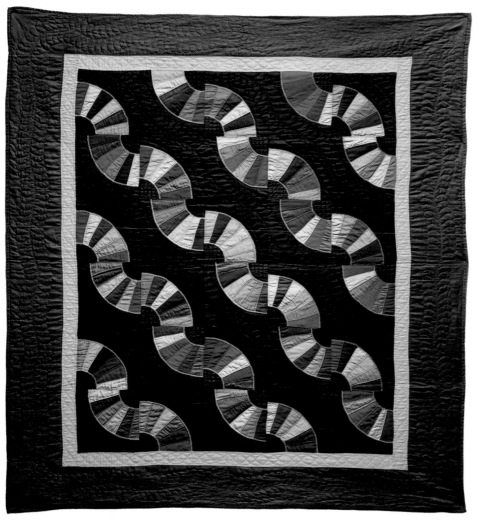

83 (left). Fans in Drunkard's Path, Pennsylvania, c. 1915. 77" x 71". Predominantly wool. This stunning combination of two quilt patterns has been constructed by the block method; the black pieces in each block are turned in different directions to suggest many shades of black. The embroidery stitching around the drunkard's path is a twentieth-century development in Amish quilts. (Mr. and Mrs. Peter Findlay)

84 (below). Double Nine-Patch, Lancaster County, 1870–1880. 84½" x 83½". Wool. The brilliant colors and the rows of green diamonds marching around the Nine-Patch design distinguish this quilt from traditional Nine-Patch bedcovers. Photograph courtesy George E. Schoellkopf Gallery. (Margot Johnson)

85 (right). Double Nine-Patch, Lancaster County, 1875–1900. 81" x 77". Wool. The creator of this quilt has varied the Nine-Patch format by connecting her diamonds with consecutive gray patches, thereby producing the illusion of stripes. Primitive tulips and clovers are stitched into the faded red borders. (Jonathan Holstein and Gail van der Hoof)

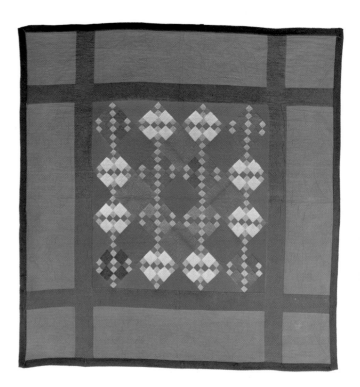

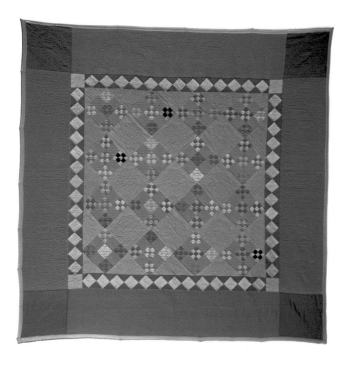

86 (right). Double Nine-Patch, Lancaster County, 1875–1900. 87" x 73". Wool. The tiny patches of this quilt are more color consistent than in most Amish quilts; rows of purple and red patches alternate with rows of black and mauve squares. In many Amish quilts the seamstress would have broken this perfect pattern with random patches of an odd color. (Jonathan Holstein and Gail van der Hoof)

87 (opposite, left above). Nine-Patch, Lancaster County, 1870–1890. 82" x 73". Wool. Some of the brown wool patches are beginning to deteriorate, perhaps due to alums added to the dyes to make them colorfast. This quilt is virtually a sampler of motifs, ranging from wreaths and feathers to baskets and tulips. (Carl and Elizabeth Safanda)

88 (opposite, left below). Double Nine-Patch, Lancaster County, c. 1910. 79" x 79". Wool. Unusual leaf fronds, resembling ferns, are stitched in the wide green borders of this elegant bedcover. (Jay and Susen Leary)

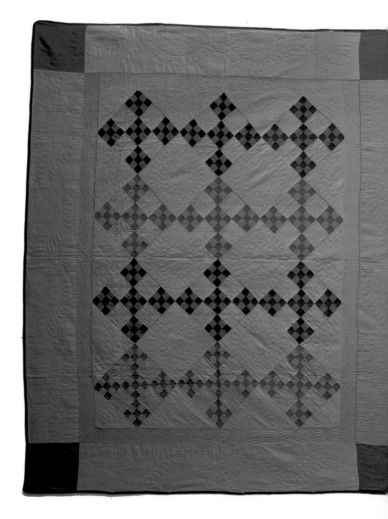

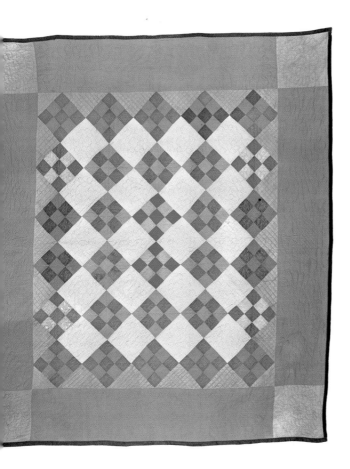

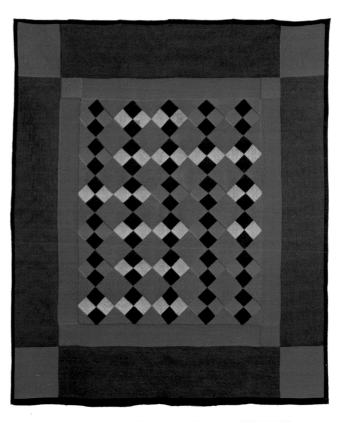

89 (above). Four-Patch, Lancaster County, 1880–1890. 82″ x 70″. Wool and cotton. This quilt combines Ohio Amish colors—black and slate blue—with a Lancaster County format—a simple Four-Patch design, wide borders, corner squares. (America Hurrah Antiques, N.Y.C.)

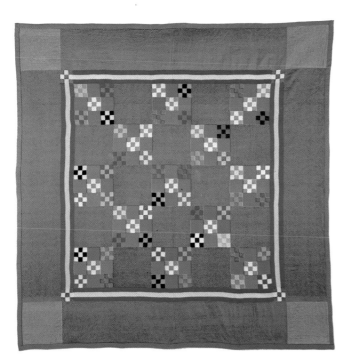

90 (right). Nine-Patch, Pennsylvania, 1900–1910. 80″ x 78″. Wool. Note how the seamstress has emphasized the corners of her design by replacing the lavender patches with darker purple ones. Stitched baskets stand out in strong relief in the wide borders. (Kelter-Malcé Antiques)

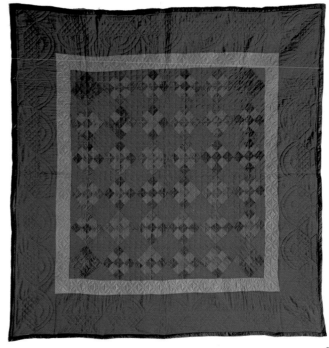

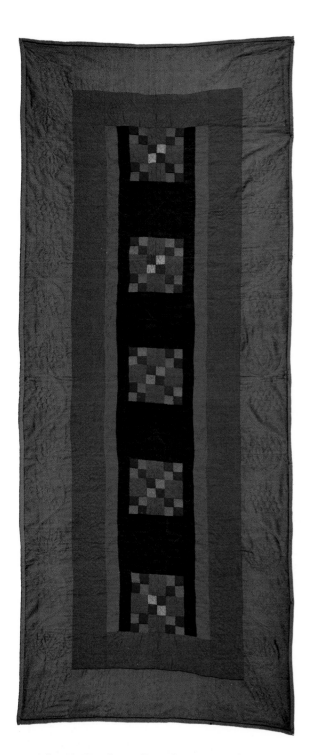

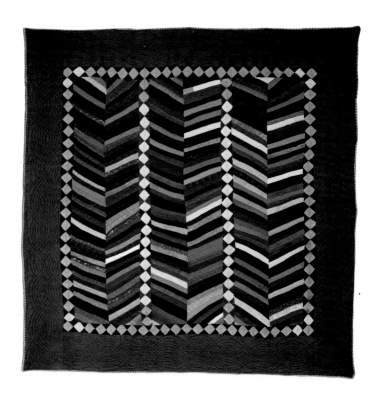

92 (above). Roman Wall quilt, Pennsylvania, c. 1900. 76″ x 73″. Cotton and wool. The elegantly arranged strips of fabric produce a three-dimensional effect, but the bedcover can still be considered a "quilt to use up" the contents of the scrap bag. (George E. Schoellkopf Gallery)

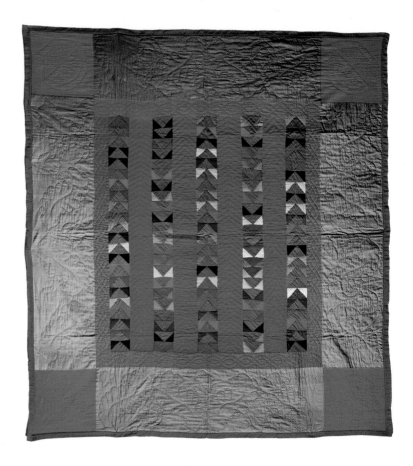

91 (above). Hired Hand's quilt, Nine-Patch variation, Lancaster County, 1900–1925. 92″ x 38″. Wool. Although this quilt is allegedly a hired hand's bedcover, its unusual dimensions suggest that it may have been intended as a coffin cover. (Ron and Marilyn Kowaleski)

93 (right). Wild Goose Chase, Lancaster County, 1880–1900. 80″ x 74″. Wool. This is an original departure from the basic Bars quilt, with small triangles forming the wild geese. The large primitive leaves stitched in the wide borders are reminiscent of the scrolls that are sometimes blind-tooled in the borders of the Amish hymnal, the *Ausbund*. (Jonathan Holstein and Gail van der Hoof)

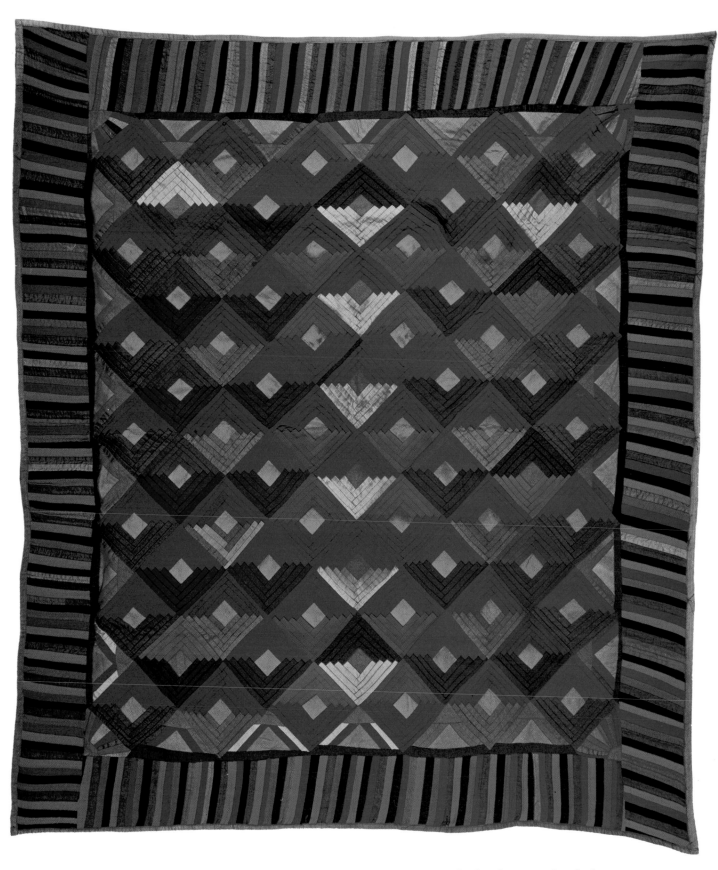

94 (above). Log Cabin, Lancaster County, 1900–1920. 79″ x 70″. Wool. The glowing red and silvery-gray strips at the center of the quilt focus the viewer's attention here. The various shadings of the green and blue strips give the diamonds a three-dimensional quality. (Mr. and Mrs. Peter Findlay)

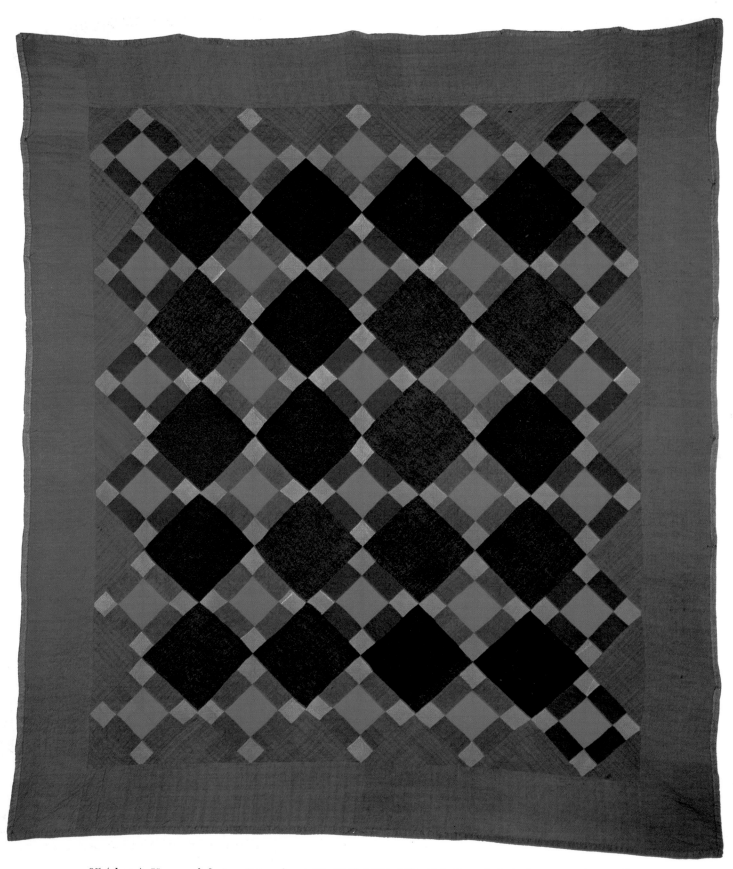

95 (above). Unnamed design, Pennsylvania(?), 1840–1860. 81″ x 73″. Stroud cloth, linsey-woolsey, and homespun. This stunning quilt is historically important because it is one of the earliest identified Amish quilts. Found in Missouri, it was most likely made in Pennsylvania because there is no evidence of Amish quilts made in the Middle West before 1860. The brilliant red squares of stroud cloth alternate with diamonds of linsey-woolsey and of homespun. The homespun patches are tweedy, grayish-black wool, more faded than the linsey-woolsey. The mulberry-colored border and the triangles around the border of the quilt were tinted with natural dyes, but the other fabrics were commercially dyed. (Jonathan Holstein and Gail van der Hoof)

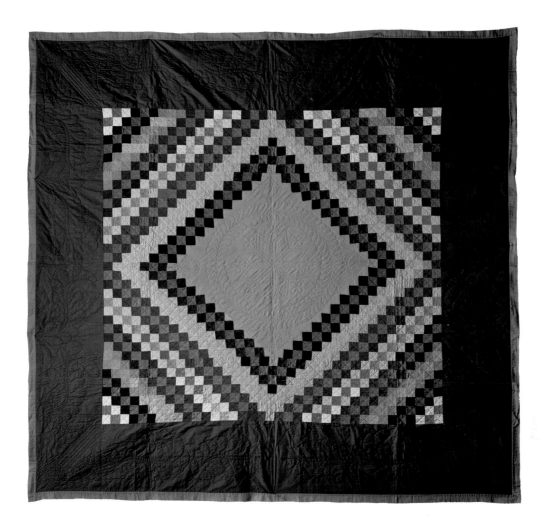

96 (above). Sunshine and Shadow variation. Lancaster County, c. 1900. 80" x 80".
Wool. The Sunshine and Shadow format has been varied by the inclusion of a large
central diamond, which is emphasized by the glowing pink wool used. Note the
tiny baskets stitched in the corners of this diamond. (America Hurrah Antiques,
N.Y.C.)

97 (right). Double Nine-Patch, Lancaster County,
1880–1900. 78" x 77". Wool. Working with four colors,
the creator of this quilt has alternated them so that the
four center Nine-Patches are the reverse colors of the
outer Nine-Patch squares. The effect of transparency is
achieved in these center patches too: red diamonds
appear to be laid over blue ones to form the light purple
diamonds. (Jonathan Holstein and Gail van der Hoof)

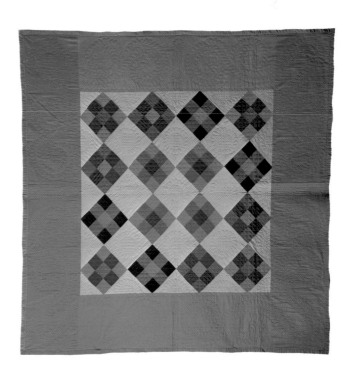

98 (below), 98a (above). Baskets, Lancaster County, 1875–1900. 76″ x 77″. Wool. The gray and purple tones of this quilt are quiet, but there is much movement in the center of the bedcover with its iridescent grayish-white and red patches. (Carl and Elizabeth Safanda)

99 (center). Baskets, Mifflin County, Pennsylvania, 1875–1900. 86″ x 74″. Wool. These geometric pieced baskets in glowing colors have a very contemporary appearance. The quiltmaker has substituted gray strips for blue ones in a random fashion and has inserted orange triangles in the upper right-hand corner to interrupt the perfect repetition of the pattern. (Mr. and Mrs. Peter Findlay)

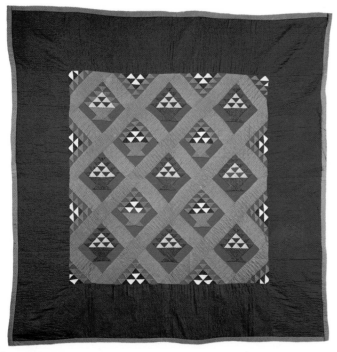

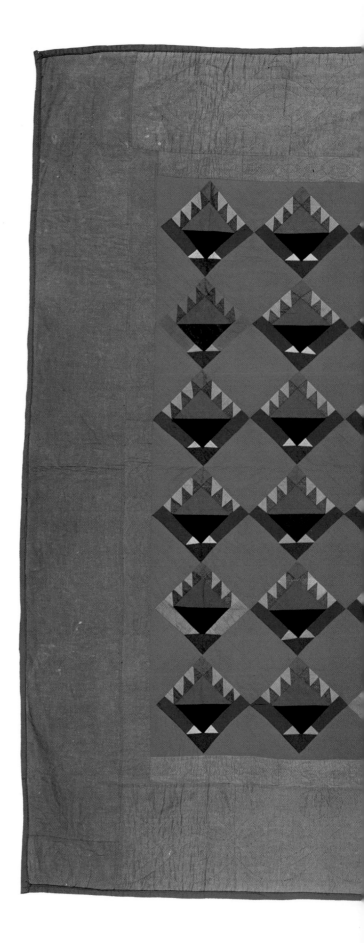

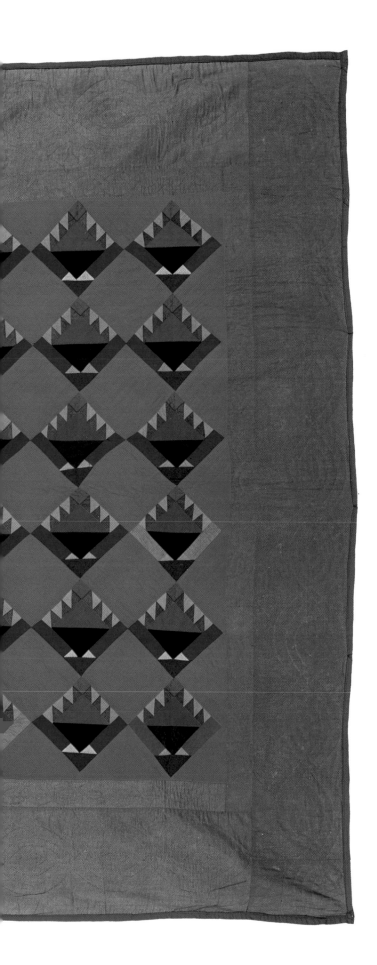

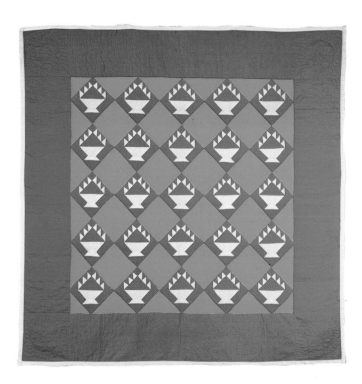

100 (above), 100a (below). Baskets, Lancaster County, 1931. 80″ x 79″. This very modern quilt constructed of cotton and some patches of crepe was made for Daniel Lapp by his mother; she embroidered his initials and the date in the center of the cranberry border. (Jay and Susen Leary)

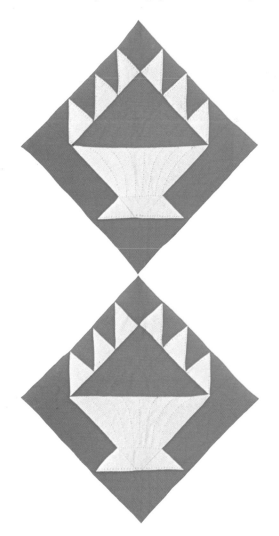

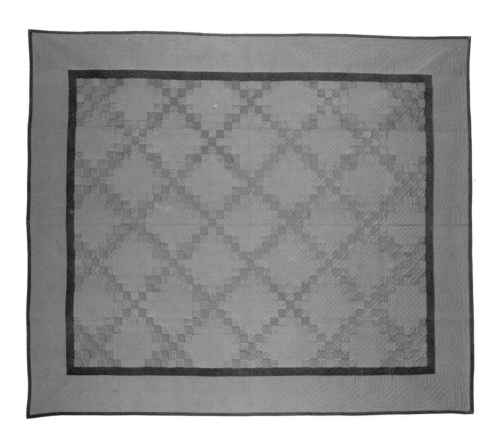

101 (above). Double Irish Chain, Missouri, 1886. 76″ x 92″. Wool. The date is quilted on the narrow inner border of this rich tobacco brown quilt. This quilt may have been sewn by an Amish woman who moved from Pennsylvania or Ohio to Missouri. (Bryce and Donna Hamilton)

102 (below). Triple Irish Chain, Lancaster County, 1900–1920. 73″ x 73″. Wool. This design gains strength because of the absence of corner squares; the Irish Chain appears to float in the dark blue field. (Carl and Elizabeth Safanda)

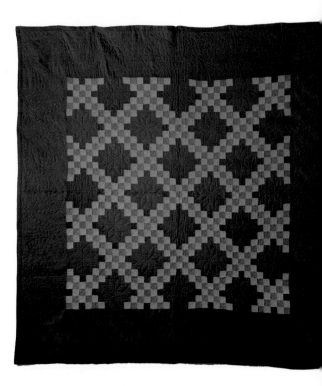

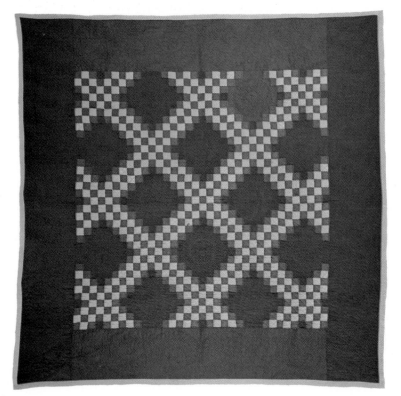

103 (above). Double Irish Chain, Lancaster County, 1898. 88″ x 86″. Wool. Amish quilts are rarely signed or dated. When they are, as in this case, the date is usually embroidered discreetly in the field or border of the quilt. (Jonathan Holstein and Gail van der Hoof)

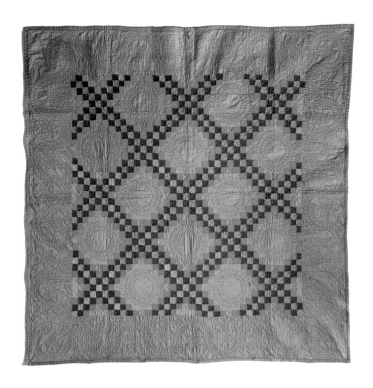

104 (left). Triple Irish Chain, Lancaster County, 1875–1890. 77" x 76". Wool. Note the very rare gridded stars that appear in the wide green borders. (Jonathan Holstein and Gail van der Hoof)

105 (below). Triple Irish Chain, Lancaster County, c. 1900. 79" x 79". Wool. This elegant quilt has wreaths that are sewn with such tiny, tight stitches that they appear raised. One can easily see the hearts stitched in each corner of the quilt as a subtle part of the feather loop. (Mr. and Mrs. Peter Findlay)

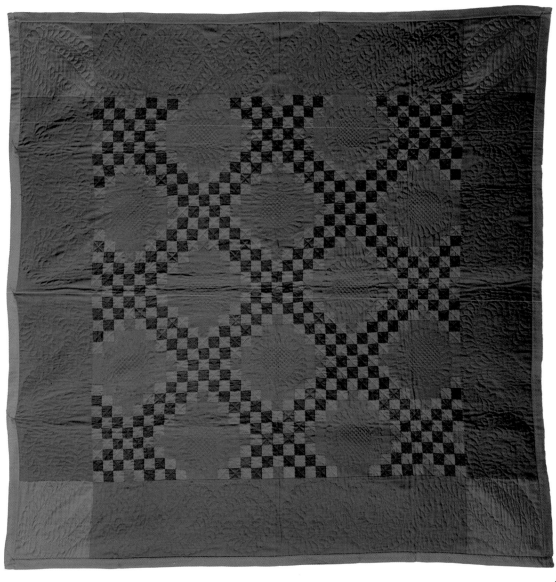

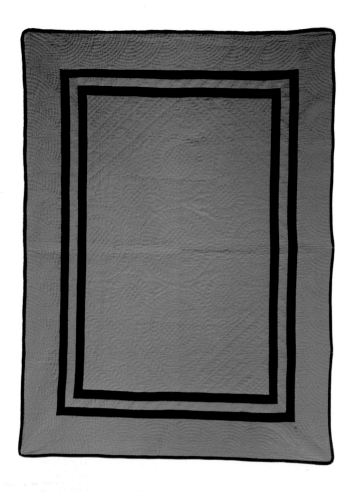

106 (left). Plain quilt, Ohio, c. 1910. 84″ x 64″. Cotton. Some church districts in Ohio, especially in Holmes County, did not allow their members to sew pieced quilts. The first step away from an absolutely plain quilt was probably this variation with its double inner border. Such quilts provided a perfect canvas for the superb quilted designs that *were* allowed. Note the tiny tulips and hearts stitched between the wreaths in the middle of this quilt. (Bryce and Donna Hamilton)

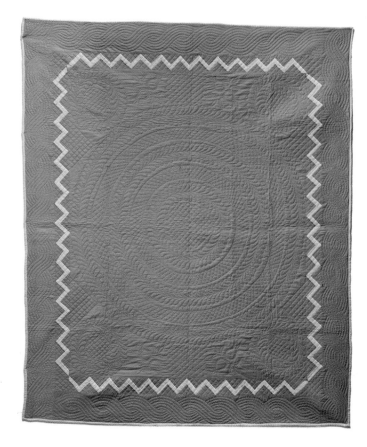

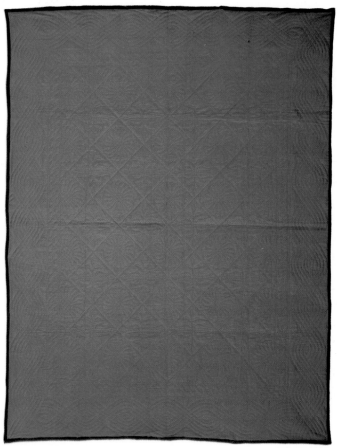

107 (left). Plain quilt, Holmes County, Ohio, 1900–1920. 88″ x 68″. Cotton. The women were allowed to stitch together two layers of cloth, usually somber in color, and secure them with fine stitches. This is a typical plain quilt with only a thin black binding or hem to offset the purple field. (Jonathan Holstein and Gail van der Hoof)

108 (above). Plain quilt, Ohio, c. 1925. 84″ x 64″. Cotton. The center medallion, corner wreaths, and flower designs are all beautifully accentuated by the zigzag border, pieced of gold cotton and then quilted. (Bryce and Donna Hamilton)

109 (opposite). Crazy Stars, Indiana, dated 1929. 88″ x 70″. Cotton and wool. The brilliant patched stars that whirl across the surface of this quilt appear like multiple images at the end of a kaleidoscope. Note how the artist has varied the intensity of the blue squares that divide the Crazy Stars like so many windows. (Phyllis Haders)

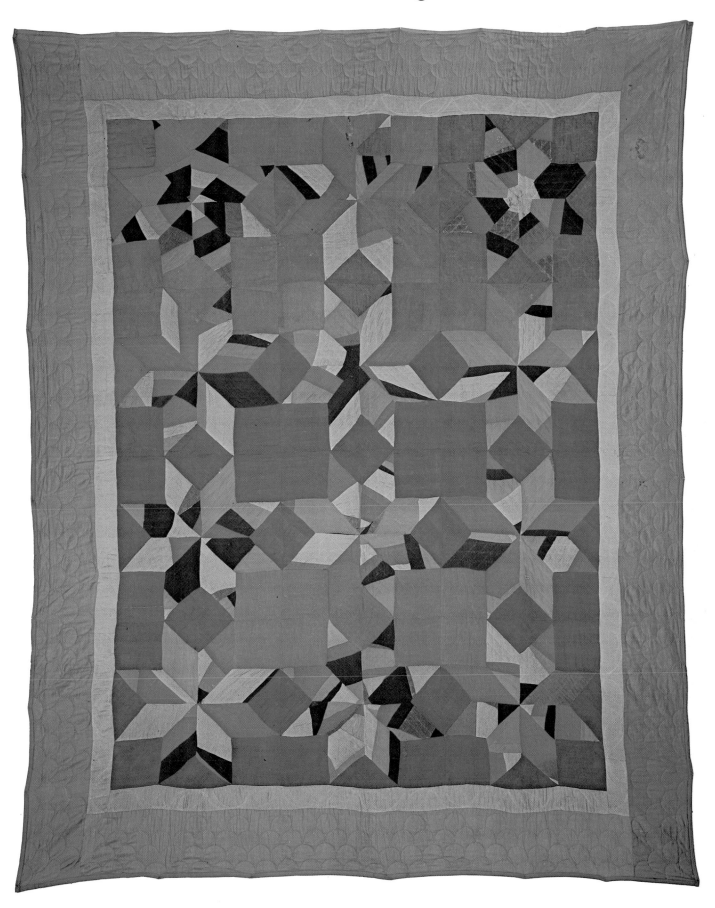

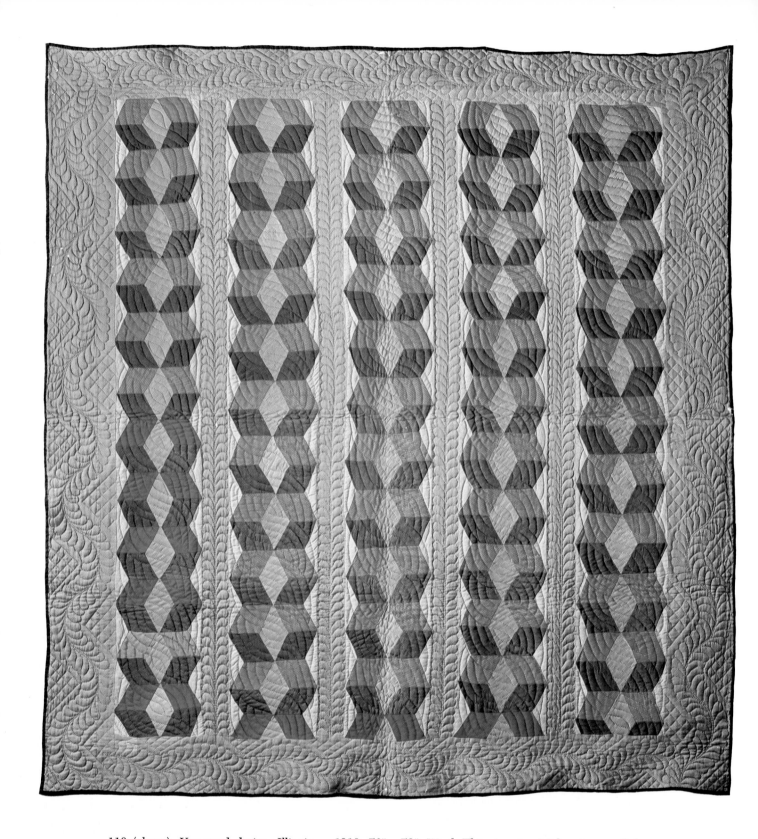

110 (above). Unnamed design, Illinois, c. 1910. 76″ x 73″. Wool. This stunning Midwestern quilt has a wonderfully modern effect; the rows of blocks in bar formation appear three-dimensional. The artist has given added depth and texture to the quilt by stretching a cable-stitched design across the rows of blocks. (Jonathan Holstein and Gail van der Hoof)

111 (right). Tree of Life, Ohio, dated May 2, 1921. 78″ x 76″. Cotton. This quilt shows the extent of the influence of the American frontier on Amish quilting designs. This was particularly true in the Midwest, where Amish women were more likely than their Pennsylvania sisters to come into close contact with "English" neighbors and "borrow" patterns like the Tree of Life, which are not traditionally Amish. (Sandra Mitchell)

112 (below, left). Double Nine-Patch, Michigan, dated 1930. 96″ x 74″. Cotton. This finely quilted bedcover in warm earth tones is highlighted with glowing gray patches in four of the Nine-Patch blocks. (America Hurrah Antiques, N.Y.C.)

113 (below, right). Checkerboard Squares, Sugarcreek, Ohio, c. 1915. 83″ x 65½″. Cotton. The twelve bright blocks in their cranberry field are scaled-down versions of the Sunshine and Shadow pattern. (Kelter-Malcé Antiques)

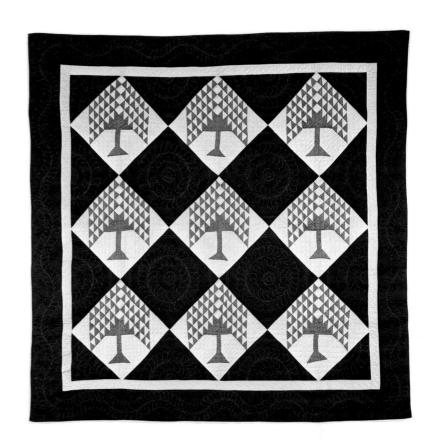

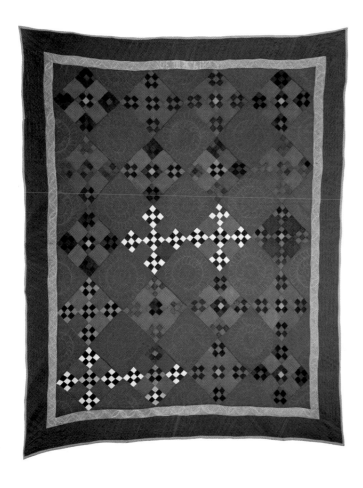

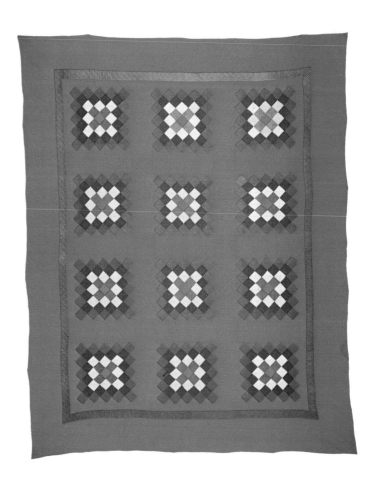

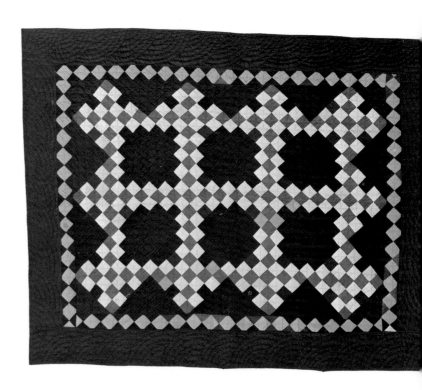

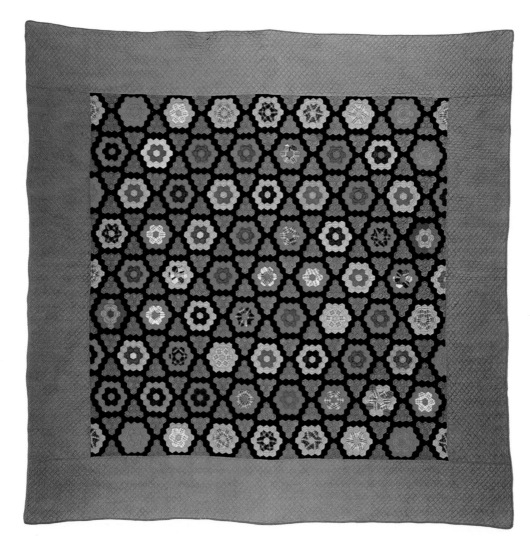

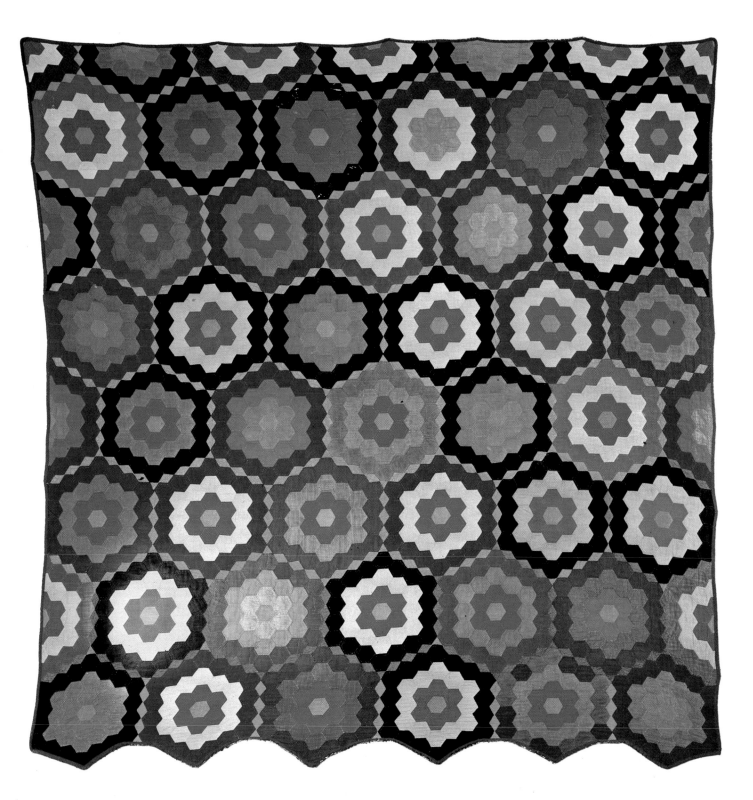

114 (opposite, above left). Crib quilt, Baskets, Ohio, c. 1920. 41″ x 32½″. Cotton. Many Ohio Amish quilts, like this scaled-down crib quilt, are composed of only two colors. (Bryce and Donna Hamilton)

115 (opposite, above right). Crib quilt, Double Irish Chain variation, Ohio, c. 1920. 34″ x 42″. Cotton. Note how the artist has handled the corners of this inner border: apparently it posed an awkward design problem, and she treated each corner differently. (Bryce and Donna Hamilton)

116 (opposite, below). Grandmother's Flower Garden, Indiana, c. 1880. 77½″ x 76¾″. Wool. The unusual features of this quilt are the especially fine waffle grid in the green borders and the use of pieces of patterned fabric in the flowers. Except for occasional early quilts from Berks County, it is rare to see sprigged or striped fabric on the face of an Amish quilt. (Blanche Robinson)

117 (above). Grandmother's Flower Garden, Shipshewana, Indiana, c. 1890. 84½″ x 81½″. Wool. In many respects this quilt illustrates the influence of the "outside society" upon Amish quilt-making techniques. The overall design and the lack of wide borders and of elaborately stitched motifs is more "English" than Amish. (Phyllis Haders)

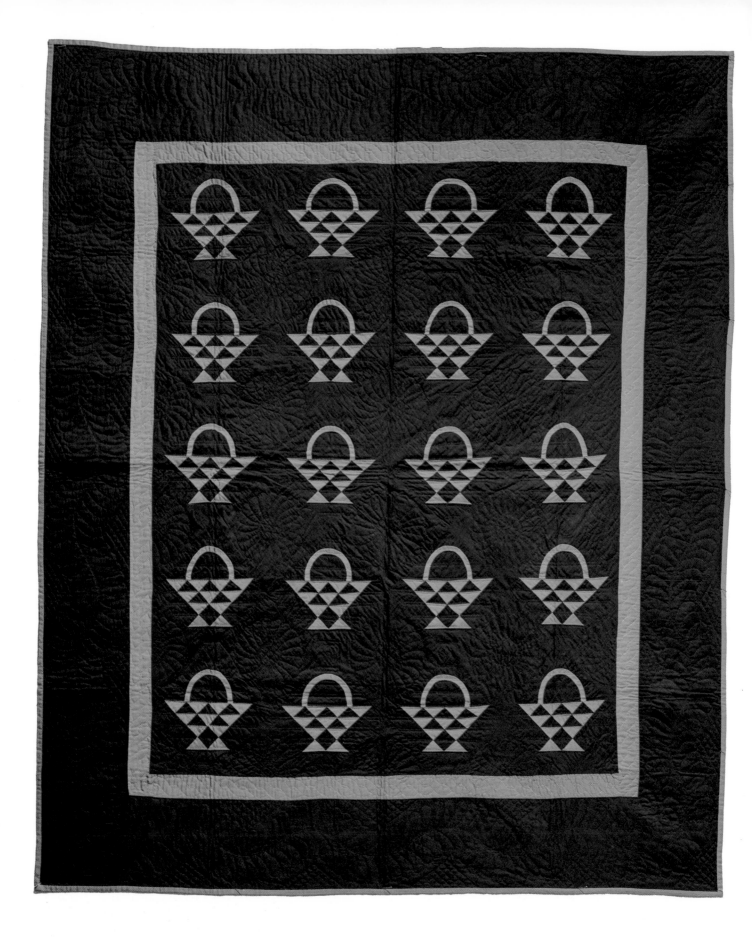

118 (above). Baskets, Ohio, c. 1930. 80" x 68". Cotton. These simple modern green baskets glow intensely in the field of blue-black cotton. This is a typical Midwestern Amish quilt of the period: cotton, rectangular, a field of black, and an overall repeated design. (Jonathan Holstein and Gail van der Hoof)

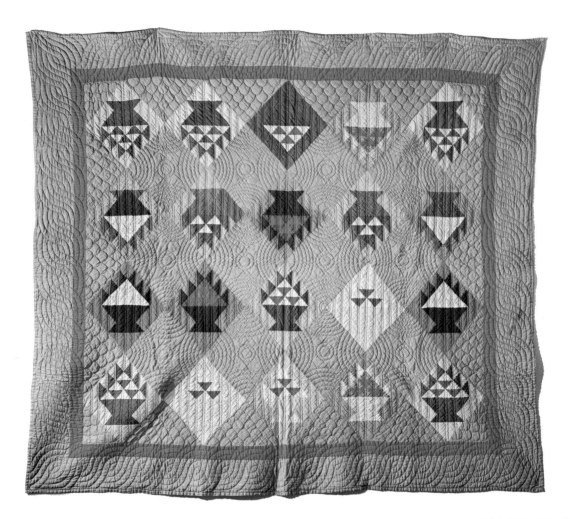

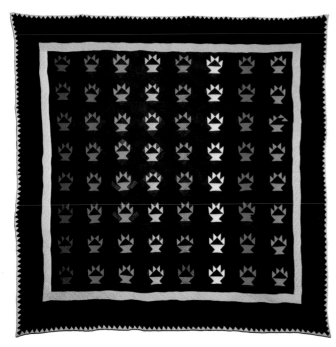

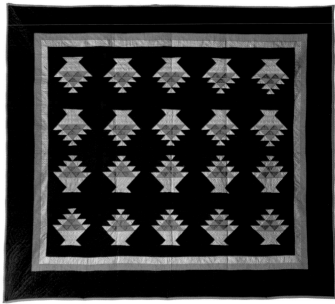

119 (above). Baskets, Indiana, c. 1910. 66″ x 78″. Cotton. The tightly woven braids in the border, the fish scale in the blue triangles, and the "sea waves" and circles in the blue diamonds are eloquent proof of the sewing skills of this Amish woman. The narrow red border sets off the inner design as effectively as a double mat on a fine old print. (Phyllis Haders)

121 (below). Baskets, Ohio, c. 1920. 68″ x 76″. Cotton. The artist has limited herself here to four strong colors and has not interrupted the symmetry of her pattern with random patches of a different color. (Bryce and Donna Hamilton)

120 (above). Baskets, Ohio, c. 1920. 82″ x 82″. Cotton. The glowing baskets that dominate this lovely Ohio quilt all but obscure the gray and black diamonds on which they are centered. The third blue basket in the last row has several triangles tilted at odd angles, undoubtedly to prevent the overall design from being perfectly symmetrical. (Susan C. Kolker)

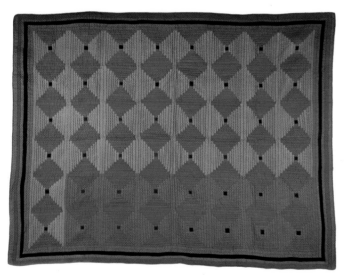

123 (below). Log Cabin, Courthouse Steps design, Ohio, c. 1940. 70″ x 84″. Cotton. This quilt incorporates all the colors of an Amish clothesline with its fluttering dresses of mauve and purple and aqua, capes and trousers of black, and shirts of blue. (Bryce and Donna Hamilton)

124 (opposite, above). Log Cabin, Barn Raising design, Ohio, c. 1920. 74″ x 78″. Cotton. The bold pink and black diamonds are softened by an overlaid grid of lighter strips of beige, gray, and blue. (Bryce and Donna Hamilton)

125 (opposite, below). Log Cabin, Barn Raising design, Indiana, c. 1920. 70″ x 76″. Cotton. The pale blue diamonds radiating from the center of the quilt give pastel overtones to this bedcover, even though the Log Cabin squares are actually composed of many red, black, and blue logs. (Phyllis Haders)

122 (above). Log Cabin, Courthouse Steps design, Indiana, c. 1910. 76″ x 82″. Cotton. The seamstress has carefully assembled many tan and brown strips, framing them with an elegant triple border, yet amazingly has pieced a broad rectangular area in a contrasting tone of brown. (Timothy and Pamela Hill)

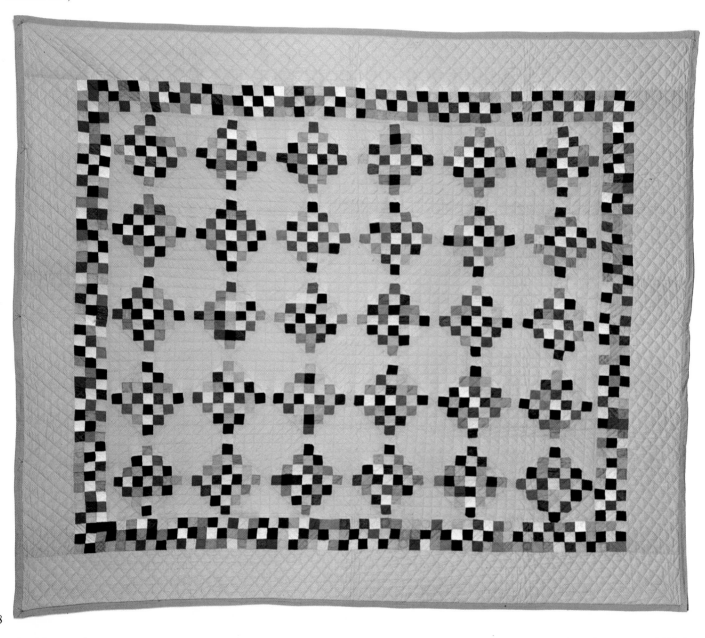

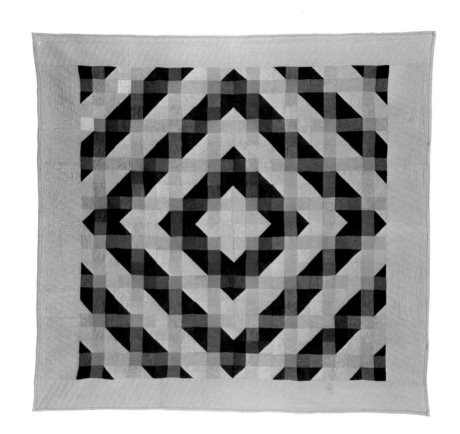

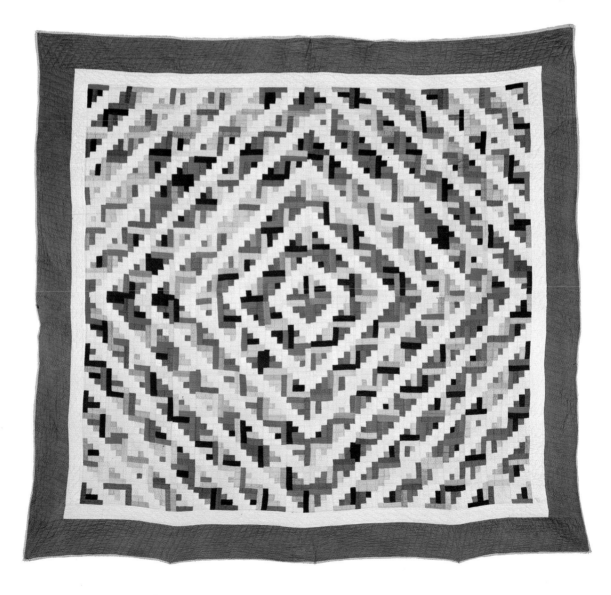

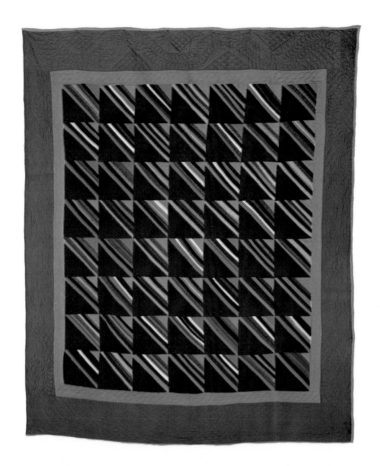

126 (left). Roman Stripes, Ohio, c. 1920. 86″ x 72″. Wool and cotton. The brilliant slashes of color that divide each square almost simulate streaks of lightning in a dark sky. (Thos. K. Woodard: American Antiques & Quilts)

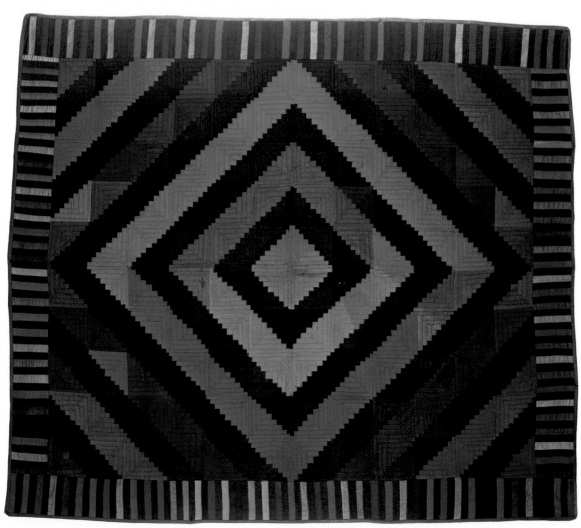

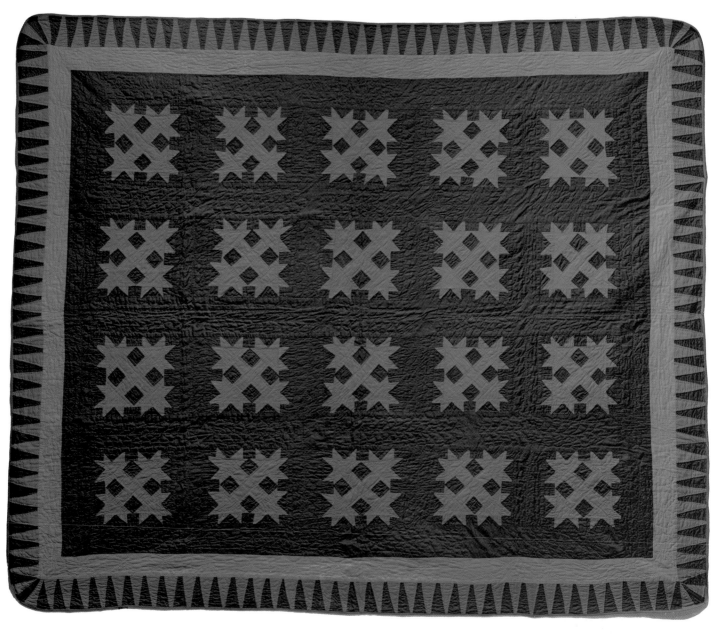

127 (opposite, below). Log Cabin, Barn Raising design, Tusca-rawas County, Ohio, 1890–1900. 62″ x 73″. Cotton and wool. In this rare, early Ohio quilt, rows of diamonds in earth tones alternate dramatically with black diamonds. In the border many of the black strips are of cotton sateen, while the rich colors are of wool materials. (Barbara S. Janos and Barbara Ross)

128 (above). Botch-Handle, Holmes County, Ohio, c. 1900. 67″ x 80″. Cotton. The quilt, which was found in the family of an Amish bishop, was made by his mother about 75 years ago and used primarily "for show" on those Sundays when religious services were held in his home. Amish women in Holmes County refer to the pattern as Botch-Handle but do not know the origin of the term. (Barbara S. Janos and Barbara Ross)

129 (right). Bow-Tie variation, Ohio, 1900–1920. 84″ x 71″. Cotton. An interesting monochromatic effect is achieved in this quilt by piecing the black blocks and triangles at different angles so that some give off more light. The cable stitching in the border and the wreaths between the bow ties are popular motifs in Ohio Amish quilts. (Ted Hicks)

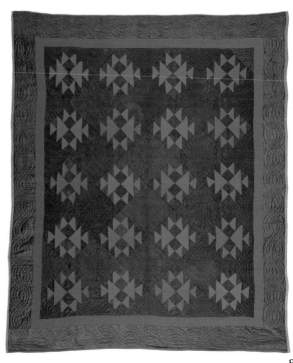

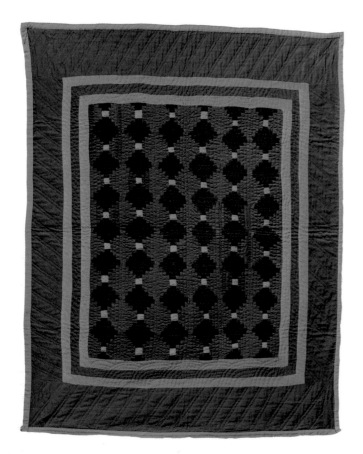

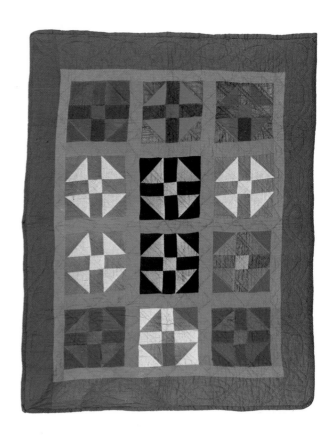

130 (above). Crib quilt, Log Cabin, Ohio, c. 1900. 38″ x 31″. Cotton. The black log cabins in the center of the quilt are carefully pieced with quarter-inch strips. (Bryce and Donna Hamilton)

131 (above, right). Crib quilt, Shoofly variation, Ohio, c. 1920. 42″ x 33″. Cotton. This quilt combines many of the favorite Amish fabric colors: mulberry, tobacco brown, black, medium, and slate blue. (Bryce and Donna Hamilton)

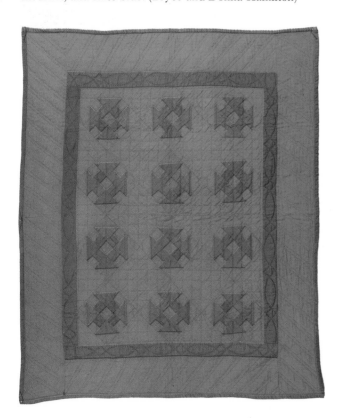

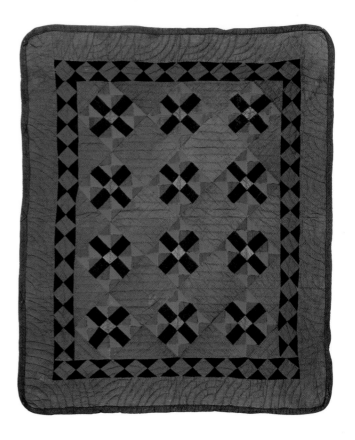

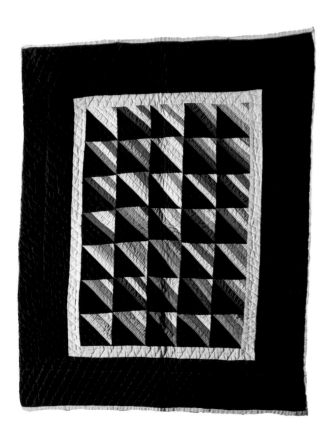

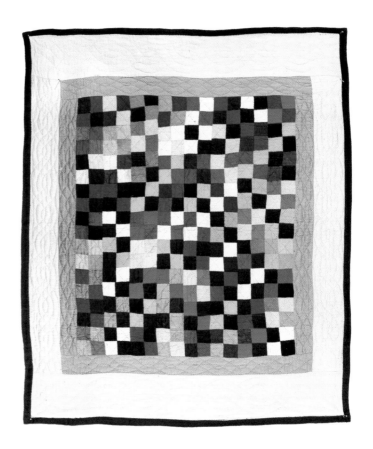

132 (opposite, below left). Crib quilt, Hole-in-the-Barn-Door, Ohio, c. 1910. 37″ x 31″. Cotton. This crib quilt bears a scaled-down design of the type often found on full-size Amish quilts. (Bryce and Donna Hamilton)

133 (opposite, below right). Crib quilt, unnamed design, Ohio, c. 1900. 37″ x 30″. Cotton. Although this design has not been given a name, it is a combination of Nine-Patch, Bow Tie, and Cross-in-the-Square. (Bryce and Donna Hamilton)

134 (above). Crib quilt, Roman Stripe variation, Ohio, c. 1930. 41½″ x 33½″. Cotton. (Bryce and Donna Hamilton)

135 (right, above). Crib quilt, Four-Patch, Ohio, c. 1920. 37″ x 31″. Cotton. The extensive use of black patches tones down the overall pastel effect of this checkerboard bedcover. (Bryce and Donna Hamilton)

136 (right, below). Crib quilt, Roman Stripe variation, Ohio, c. 1930. 59″ x 37″. Cotton. The seamstress who created this quilt obviously relied on her scrap bag, for some of the diagonal stripes are pieced with different colors. Although each series of diagonal stripes begins with a light beige patch, the order of the following stripes does not remain constant throughout the quilt. (Bryce and Donna Hamilton)

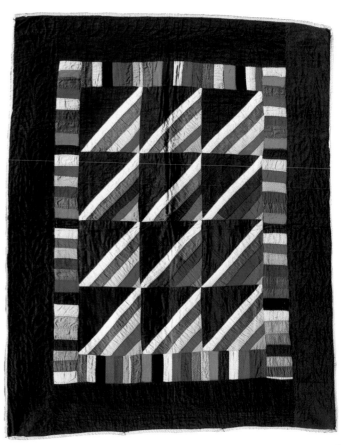

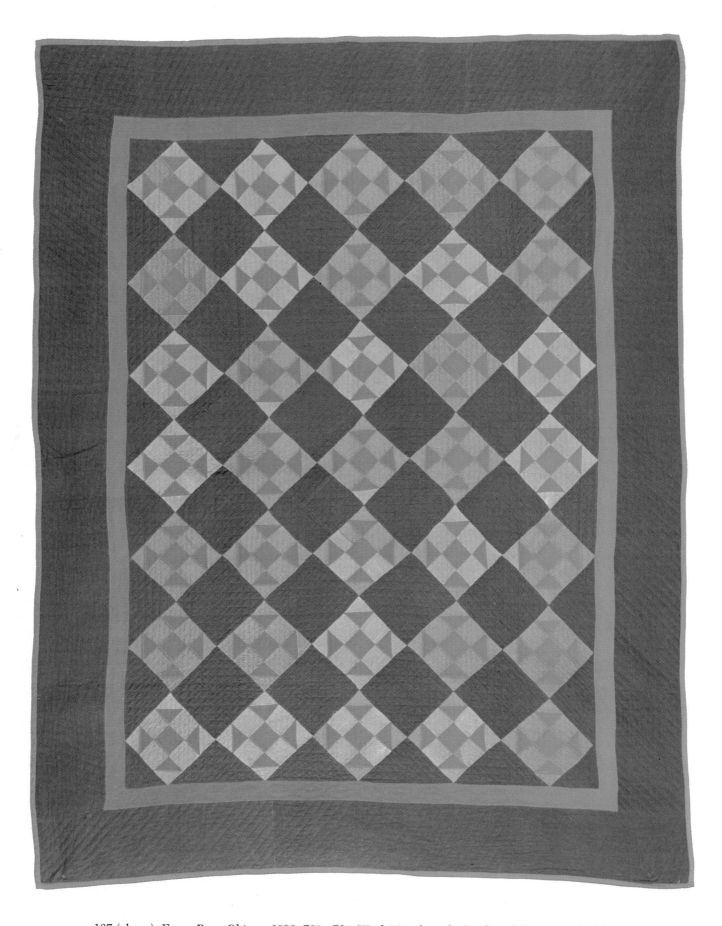

137 (above). Fence Row, Ohio, c. 1890. 78″ x 72″. Wool. Note how the bright red designs in the blue diamonds are similar to ventilator grilles cut into the peak of the Amish barn shown in figure 13. (Timothy and Pamela Hill)

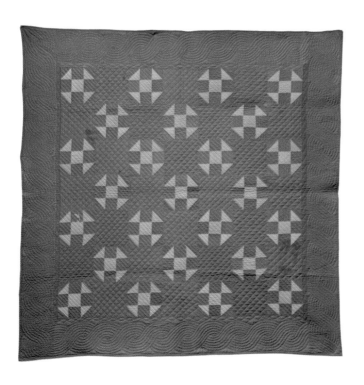

138 (left). Shoofly, Ohio, c. 1910. 74" x 74". Cotton. The gold shoofly patches are suspended like stars in the deep blue "sky." The pattern of this quilt gets its name from a wild plant with domed flowers. (Bryce and Donna Hamilton)

139 (below). Unnamed design, Indiana, c. 1920. 68" x 86". Cotton. The intricate square-within-a-diamond-within-a-square motif of this quilt is strikingly similar to the Center Diamond variation from Lancaster County seen in figure 25. (Bryce and Donna Hamilton)

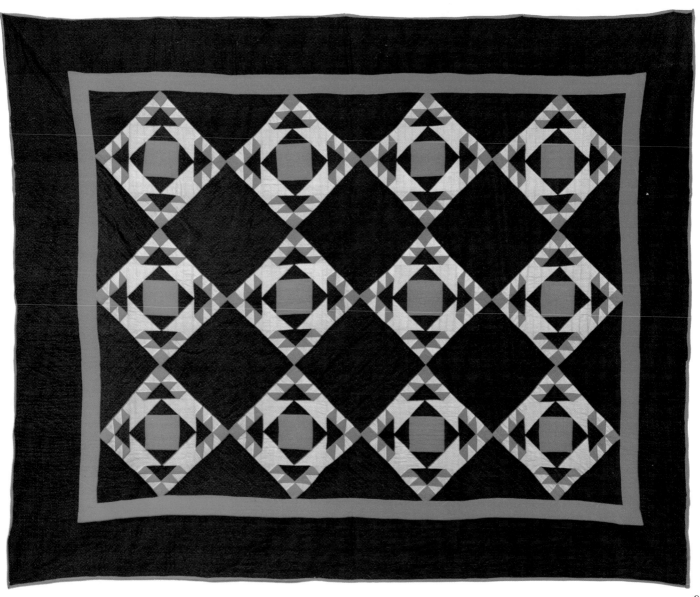

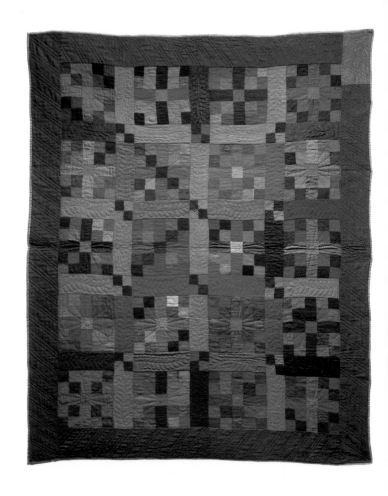

140 (right). Cross-in-the-Square, Indiana, c. 1900. 87″ x 69″. Wool. Both the overall design and the quilting of this bedcover are unique: note the flower petals stitched in the center of each square and the feathers that decorate the borders separating the squares. (Bryce and Donna Hamilton)

141 (below, left). Diagonal Triangles, Ohio, 1900–1910. 88½″ x 66″. Wool. The rich red, brown, and purple patches that make up this quilt are shaded with stripes of a different tone, probably out of frugal rather than aesthetic considerations. (Albert Eisenlau Gallery)

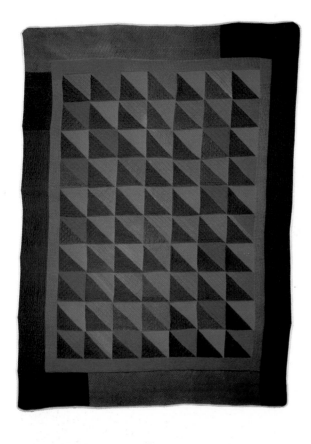

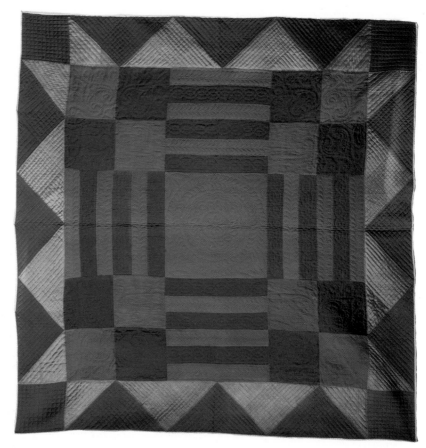

142 (opposite, below right). Unnamed design, Iowa, 1930–1940. 80½″ x 79½″. Wool. The design of this quilt is absolutely original to the seamstress. (Bryce and Donna Hamilton)

143 (below). Star-Within-a-Star, Iowa, c. 1935. 91″ x 80½″. Wool. The many borders of this original quilt compose a veritable catalogue of stitched motifs, as though the seamstress were subtly trying to show off her mastery of the various quilting designs. Roses, fish scale, cables, double circles, vines, and tulips are all found in this unique quilt. (Bryce and Donna Hamilton)

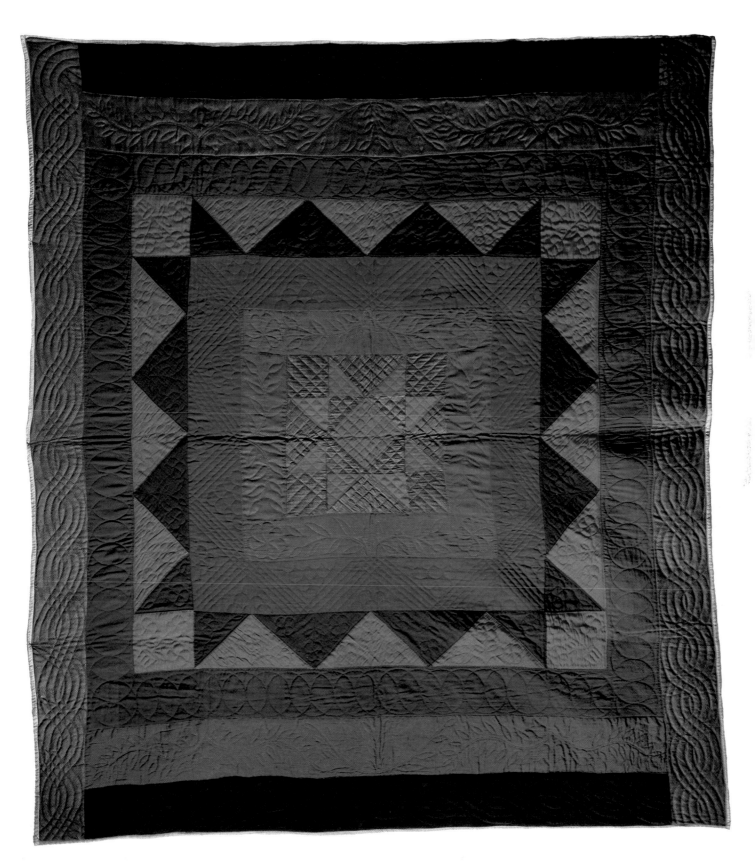

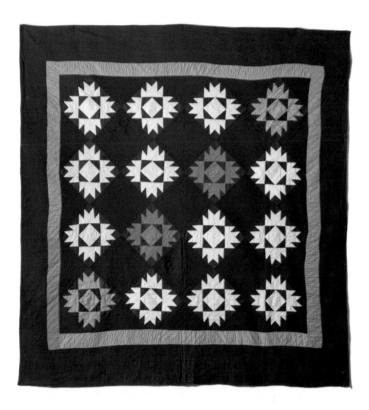

144 (above). Bear Paw, Ohio, c. 1920. 82″ x 78″. Cotton. The design of this quilt is a favorite of the Amish in the Midwest: a repeated overall pattern in pastel or bright hues on a field of black. (Kelter-Malcé Antiques)

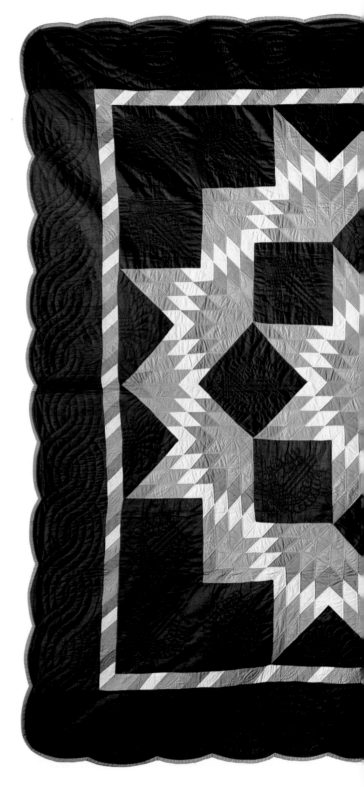

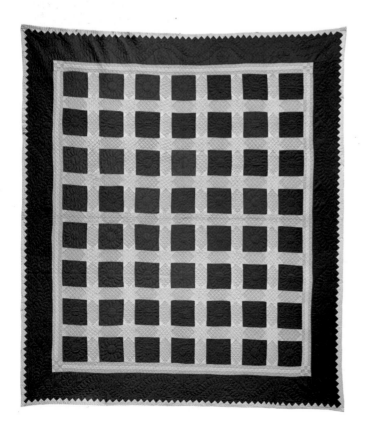

145 (left). Stars and Stripes, Ohio, c. 1920. 86½″ x 77″. Cotton. This quilt is backed with white cotton sheeting stamped "Florentine Sheeting Co.," probably bought expressly for quilting. (Carl and Elizabeth Safanda)

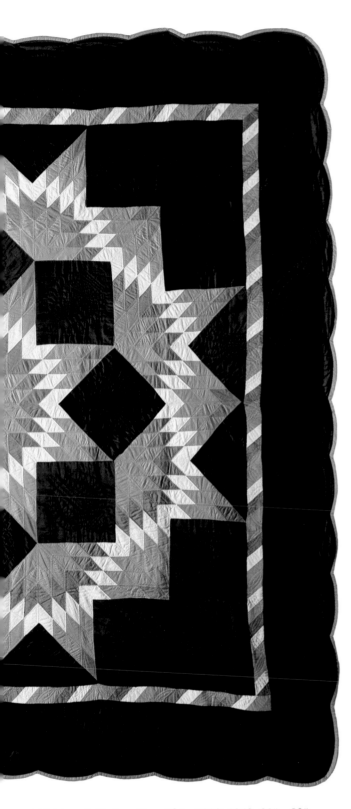

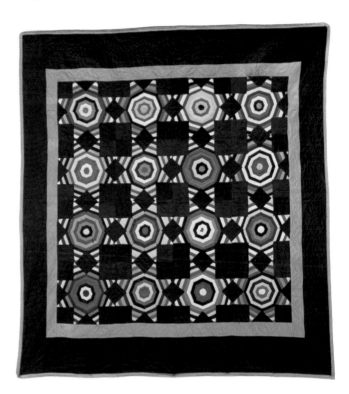

147 (below). Spider Web, Ohio, c. 1930. 84″ x 74″. Cotton. The dazzling design of this quilt resembles the view at the end of a kaleidoscope: motion and color and repeating patterns. No two stars in the overall design are exactly alike. (Bryce and Donna Hamilton)

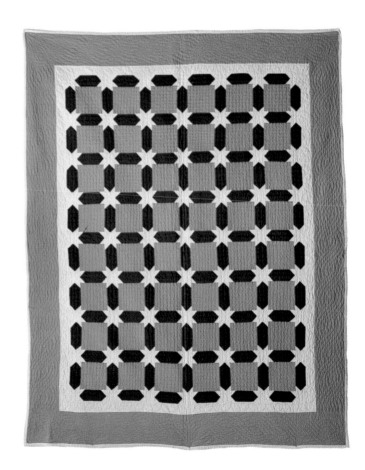

146 (above). Broken Star, Ohio, 1930–1940. 83″ x 82″. Cotton. Although this quilt is a relatively recent one, it is a unique example of craftsmanship: the eight black diamonds, finely quilted with lyre designs, break up the larger star into two brilliant stars. (Bryce and Donna Hamilton)

148 (right). Eight-Pointed Star, Ohio, c. 1920. 80″ x 75″. Cotton. This quilt pattern has also been called Stars and Stripes; note how the yellow patches form broken diagonal stripes. (Bryce and Donna Hamilton)

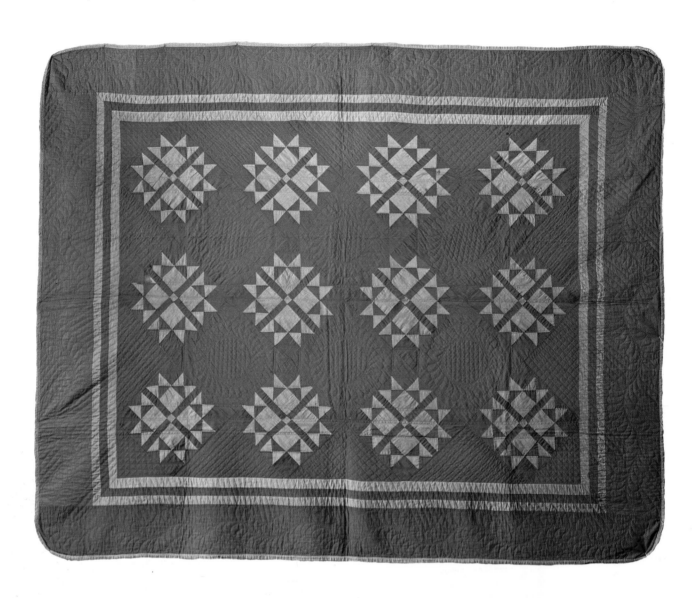

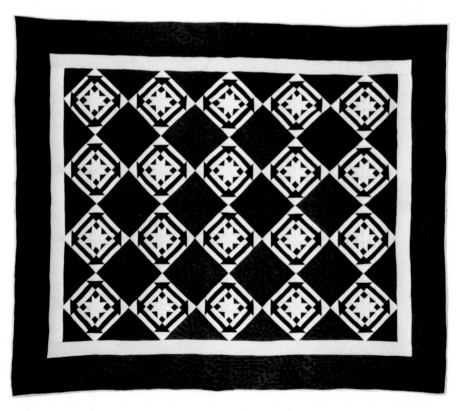

90

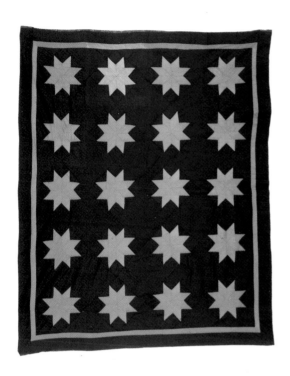

149 (opposite, above). Variable Star, Ohio, 1900–1910. 68″ x 84″. Cotton. This color combination is a popular one in Ohio Amish quilts. (Jonathan Holstein and Gail van der Hoof)

150 (opposite, below). Original combination of Eight-Pointed Star and Hole-in-the-Barn-Door, Indiana, 1934. 71″ x 84″. Cotton. Superb quilting in the border and between the diamonds gives this quilt additional texture. An unusual touch: the date of completion, March 1, 1934, is embroidered on the quilt. (Bryce and Donna Hamilton)

151 (left). Eight-Pointed Star, Ohio, c. 1920. 83″ x 68″. Cotton. (Patricia and James Rutkowski)

152 (below). Eight-Pointed Star, Ohio, c. 1910. 70″ x 80″. Cotton. The uncluttered design of this quilt is a dynamic one, with bright-colored stars framed by bold red strips. (Bryce and Donna Hamilton)

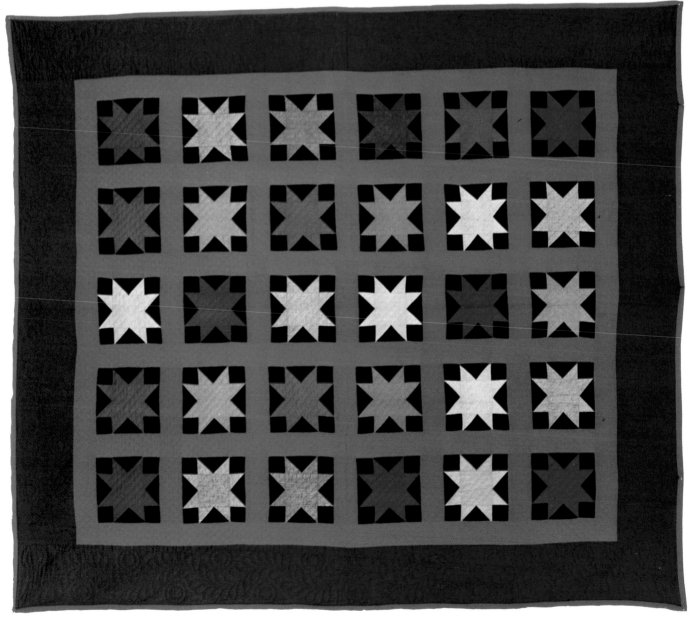

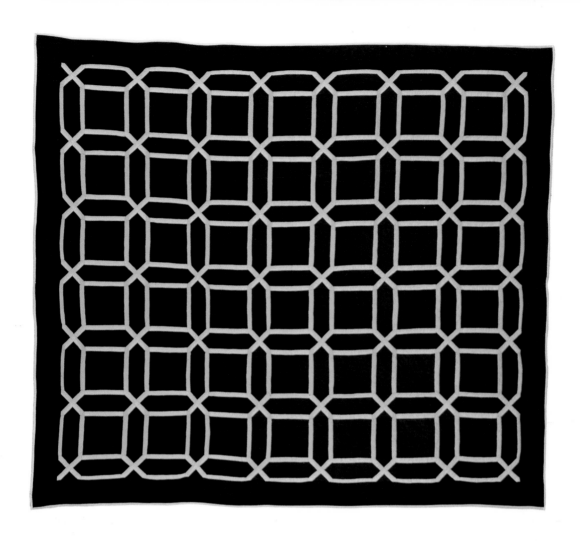

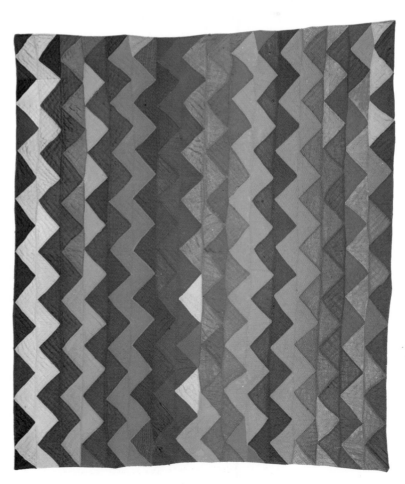

153 (above). Honeycomb, Ohio, c. 1920. 72″ x 80″. Cotton. This is a brilliant quilt, both in color and in overall design, which resembles an abstract neon sign. It is astonishing that the relatively isolated Amish created such dynamic modern designs. (Bryce and Donna Hamilton)

154 (right). Zigzag (Streak o' Lightning), Ohio, 1900–1915. 74″ x 66″. Wool. The dramatic impact of this bold wool quilt is achieved with rich colors and an overall design uninterrupted by multiple borders or corner squares. (Kelter-Malcé Antiques)

155 (opposite, above left). Diagonal Triangles, Ohio, c. 1930. 86″ x 80″. Cotton. The arrangement of colors and the slant of the triangles in this quilt produce the sensation of movement from left to right. (Bryce and Donna Hamilton)

157 (opposite, below). Bear Paw variation, Ohio c. 1925. 75″ x 75″. Cotton. Note how the cable motif quilted in the wide border is repeated throughout the field of the quilt. (Bryce and Donna Hamilton)

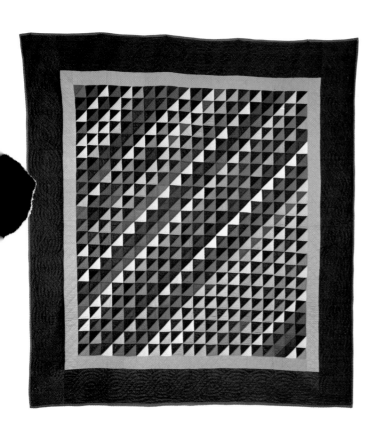

156 (below). Bow Tie, Ohio, c. 1925. 73" x 80". Cotton. In this sophisticated quilt the black bow ties moving in one direction contrast powerfully with the pastel bow ties moving in the opposite direction. This quilt is unusual in its use of white, which rarely appeared in Amish quilts before 1940. White was generally reserved for funeral garb. (Bryce and Donna Hamilton)

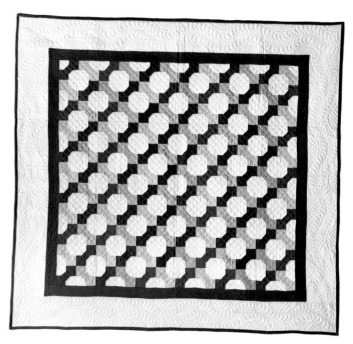

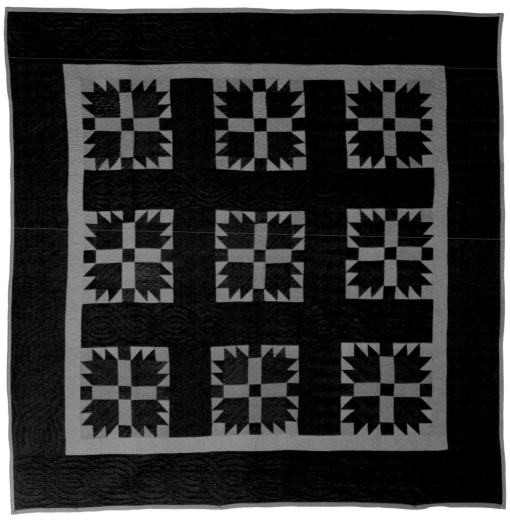

NOTES

1. This is the popular term for the Pennsylvania Germans, the Deutscn.

2. Phebe Earle Gibbons, *Pennsylvania Dutch and Other Essays* (Philadelphia: Lippincott & Co., 1882), p. 44.

3. John Kouwenhoven, *Made in America* (Garden City, N.Y.: Doubleday & Co., Inc., 1949), p.118.

4. Horation Greenough, *The Travels, Observation, and Experiences of a Yankee Stonecutter* (Gainesville, Fla.: Scholars' Facsimiles and Reprints, 1958), p. 172.

5. A church district is both a geographical area and a spiritual community, encompassing about 40 to 50 Amish families.

6. Kenneth Ronald Davis, *Anabaptism and Asceticism* (Scottdale, Pa.: Herald Press, 1974), p. 75.

7. John Joseph Stoudt, *Pennsylvania German Folk Art: An Interpretation* (Allentown, Pa.: Schlecter's, 1966), p. 101.

8. The Colonial Records: Minutes of the Provisional Council of Pennsylvania (Harrisburg, Pa., 1851), p. 173.

9. Redmond Conyngham, *Hazard's Pennsylvania Register*, 7 (March 5, 1831), pp. 150–151.

10. Gertrude Huntington, "A Dove at the Window: A Study of an Old Order Amish Community in Ohio (Ph.D. diss., Yale University, 1957), p. 105.

11. Don Yoder, "Plain Dutch and Gay Dutch: Two Worlds in the Dutch Country," *The Pennsylvania Dutchman*, 8, no. 1 (Summer 1956), p. 41.

12. Amelia M. Gummere, *The Quaker: A Study in Costume* (Philadelphia: Ferris and Leach, 1901), p. 11.

13. For an excellent discussion of this phenomenon, see John A. Hostetler in "Amish Use of Symbols and Their Function in Bounding the Community," *Journal of the Royal Anthropological Institute*, 94, no. 1 (1963), pp. 11–22.

14. Of course, over the years this boundary has fluctuated, expanding and contracting according to the conservatism of the community, and we have seen corresponding changes in Amish quilts. Gertrude Huntington discusses the testing of the boundary by restless or deviant members of the community: "There remain many who are constantly pushing at the boundaries. Most of the straining occurs in areas of economic behavior but it is also evident in other areas. There are always those who see how much they can deviate from the dress regulations: women wearing brighter colors with just the hint of pattern or shape in the material, and pleating their Kapps in slightly different ways, children being dressed in sculptured cotton and babies with nylon aprons. . . . There are also those who want as much decoration as is permitted in the house furnishings. One woman puts a small molding of flowers in an upstairs bedroom, another longs to have an outdoor scene painted in the bathroom by the local sign painter. . . . These primarily involve small changes, but they are very important to the individual and eventually they move the boundary" "A Dove at the Window," p. 218.

15. Instead of a fly closing, broadfall trousers have a latch or flap that buttons at the waist, at the sides, and front.

16. John Martin Vincent, *Costume and Conduct in the Laws of Basel, Bern, and Zurich, 1370–1800* (Baltimore, Md.: Johns Hopkins Press, 1935), p. 139.

17. Gibbons, *Pennsylvania Dutch*, pp. 16–17.

18. Ann Hark, *Blue Hills and Shoofly Pie* (Philadelphia: J.B. Lippincott, 1952), p. 122.

19. A partial quote from the Pike County, Ohio, *Artikel und Ordnungen*, published in English in 1950 (Baltic, Ohio: J. A. Raber, 1954).

20. "Dress," *The Mennonite Encyclopedia*, (Scottdale, P Mennonite Publishing House, 1955–1959), p. 99.

21. H. M. J. Klein, ed., *A History of Lancaster County Pennsylvania,* Vol. 1 (New York: Lewis Historical Publishing Co., 1924), p. 368.

22. Kouwenhoven, *Made in America*, pp. 3–4.

23. A Farm Hand's Diary, typewritten manuscript, Archives of the Mennonite Church, Goshen, Indiana, 1940, p. 38.

24. Barthinius Wick, *The Amish Mennonites* (The State Historical Society of Iowa, 1894), p. 18.

25. Susan Stewart, "Sociological Aspects of Quilting in Three Brethren Communities in Southeastern Pennsylvania," *Pennsylvania Folklife* (Spring 1974), p. 25.

26. Frances Lichten, *Folk Art of Rural Pennsylvania* (New York: Charles Scribner's and Sons, 1946), p. 227.

27. John A. Hostetler and Gertrude E. Huntington, *Children in Amish Society* (New York: Holt, Rinehart and Winston, 1971), p. 110.

28. Kouwenhoven, *Made in America*, p. 16.

29. Interview with Gertrude Huntington, Guest Lecturer, Yale University, New Haven, Connecticut, November 20, 1975.

30. *Ibid.*

31. Jonathan Holstein, *The Pieced Quilt: An American Design Tradition* (Greenwich, Conn.: The New York Graphic Society, Ltd., 1973), p. 88.

32. Amish women who engage in Relief Sewing for the Mennonite Central Committee may use printed fabrics or solid fabrics in bright hues that they might not use in their own quilts—perhaps pink or orange or bright red.

33. Huntington, "A Dove at the Window," p. 691.

34. It was commonplace for Amish correspondents to refer to the wives or the households by using the husband's name; thus the last citation refers to Mrs. Baumgardner.

35. Rita J. Androsko, *Natural Dyes and Home Dyeing* (New York: Dover Publications, Inc., 1971), p. 34.

36. Conyngham, *Hazard's Pennsylvania Register*, p. 150.

37. Homer Tope Rosenberger, *The Pennsylvania Germans, 1891–1965* (The Pennsylvania German Society, 1966), pp. 38–39.

38. Androsko, *Natural Dyes and Home Dyeing*, p. 40.

39. Rosenberger, *The Pennsylvania Germans, 1891–1965*, p. 40.

40. "Rothenfelder, Jorg Propst," *The Mennonite Encyclopedia*, p. 365.

41. Frances Lichten, *Folk Art of Rural Pennsylvania* p. 168.

42. Charles Rice and Rollin C. Steinmetz, *The Amish Year* (New Brunswick, N.J.: Rutgers University Press, 1956), p. 50.

43. William Schreiber, *Our Amish Neighbors* (Chicago: University of Chicago Press, 1962), p. 66.

44. Walter E. Boyer, "The Meaning of Human Figures in Pennsylvania Dutch Folk Art," *Pennsylvania Folklife* (Fall 1960), p. 9.

45. Holstein, *The Pieced Quilt*, plate #95.

46. Huntington, "A Dove at the Window," p. 119.

47. *Ibid.*, p. 116.
48. Averil Colby, *Patchwork Quilts* (New York: Charles Scribner's Sons, 1965), p. 9.
49. Patsy and Myron Orlovsky, *Quilts in America* (New York: McGraw-Hill Book Company, 1974), p. 251.
50. L. G. G. Ramsey, ed., *The Complete Encyclopedia of Antiques* (New York: Hawthorn Books, Inc., 1962), p. 105.
51. Eleanor Whitmore, "Origins of Pennsylvania Folk Art," The Magazine *Antiques* (September 1940), p. 109.
52. John Joseph Stoudt, *Sunbonnets and Shoofly Pies* (Cranbury, N.J.: A. S. Barnes, 1973), p. 143.
53. John Joseph Stoudt, *Pennsylvania German Folk Art,* p. 105.

54. Scott Francis Brenner, *The Plain and the Fancy* (Harrisburg, Pa.: The Stackpole Co., 1957), p. 93.
55. Matthew 6:28–29.
56. Stoudt, *Pennsylvania German Folk Art*, p. 107.
57. *Ibid.*, p. 111.
58. An Interview with David Luthy, Director, The Amish Historical Library, Aylmer, Ontario, November 6, 1975.
59. Kouwenhoven, *Made in America*, p. 245.
60. John A. Hostetler, *Amish Society* (rev. ed.; Baltimore, Md.: Johns Hopkins Press, 1968), p. 341.
61. Millen Brand and George Tice, *Fields of Peace* (New York: Dutton Paperbacks, 1973), p. 63.

SELECTED BIBLIOGRAPHY

Albers, Josef. *Interaction of Color.* New Haven, Conn.: Yale University Press, 1975.

Androsko, Rita J. *Natural Dyes and Home Dyeing.* New York: Dover Publications, Inc., 1971.

Artikel und Ordnungen der Christlichen Gemeinde in Christo Jesu. Baltic, Ohio: J. A. Raber, 1954.

Bachman, Calvin George. *The Old Order Amish of Lancaster County, Pennsylvania.* Norristown, Pa.: Pennsylvania German Society, 1942.

Barger, Eva. "Grandma's Quilt." *Mennonite Life,* 1 (October 1948), p. 12.

Bishop, Robert. *New Discoveries in American Quilts.* New York: E. P. Dutton & Co., Inc., 1975.

Boyer, Walter E. "The Meaning of Human Figures in Pennsylvania Dutch Folk Art." *Pennsylvania Folklife,* 2 (Fall 1960), pp. 5–9.

Brand, Millen, and Tice, George. *Fields of Peace.* New York: Dutton Paperbacks, 1973.

Brenner, Scott Francis. *The Plain and the Fancy.* Harrisburg, Pa.: The Stackpole Co., 1957.

Colby, Averil. *Patchwork Quilts.* New York: Charles Scribner's Sons, 1965.

The Colonial Records: Minutes of the Provisional Council of Pennsylvania. Harrisburg, Pennsylvania, 1851.

Cooper, Thomas. *A Practical Treatise on Dyeing and Callicoe Printing: Exhibiting the processes in the French, German, English and American practice of fixing colours on woollen, cotton, silk, and linen.* Philadelphia: Thomas Dobson, 1815.

Davis, Kenneth Ronald. *Anabaptism and Asceticism.* Scottdale, Pa.: Herald Press, 1974.

Denlinger, Donald, and Warner, James. *The Gentle People.* New York: Grossman Publishers, 1969.

Denton, William. *Old Quilts.* Maryland: Privately printed, 1946.

Downs, Joseph. *The House· of the Miller of Millbach.* Philadelphia: Pennsylvania Museum of Art, 1929.

Dreppard, Carl. "Origins of Pennsylvania Folk Art." The Magazine *Antiques*, 37 (February 1940), pp. 64–68.

Earle, Alice Morse. *Costumes of Colonial Times.* New York: Scribner's and Sons, 1917.

———. *Two Centuries of Costume in America.* New York: Macmillan, 1910.

Eshleman, H. Frank. *Historic Background and Annals of the Swiss and German Pioneer Settlers of Southeastern Pennsylvania.* Lancaster, Pa., 1917.

A Farm Hand's Diary. Typewritten Manuscript, Archives of the Mennonite Church, Goshen, Indiana, 1940.

Gibbons, Phebe Earle. *Pennsylvania Dutch and Other Essays.* Philadelphia: Lippincott & Co., 1882.

Gingerich, Melvin. *Mennonite Attire Through Four Centuries.* Pennsylvania German Society, 1970.

Greenough, Horatio. *The Travels, Observations, and Experiences of a Yankee Stonecutter.* Gainesville, Fla.: Scholars' Facsimiles and Reprints, 1958.

Gummere, Amelia Mott. *The Quaker: A Study in Costume.* Philadelphia: Ferris and Leach, 1901.

Hark, Ann. *Blue Hills and Shoofly Pie.* Philadelphia: J. B. Lippincott, 1952.

Hayes, A. Reed, Jr. *The Old Order Amish Mennonites of Pennsylvania.* Lewistown, Pa.: Mifflin County Historical Society, 1946.

Hazard's Register of Pennsylvania. 7 (February 26 and March 5, 1831).

Heard, Audrey, and Pryor, Beverly. *Complete Guide to Quilting.* Des Moines, Iowa: Creative Home Library, 1974.

Hershey, Mary Jane. "A Study of the Dress of the Old Mennonites of the Franconia Conference, 1700–1953." *Pennsylvania Folklife* (Summer 1958), pp. 24–47.

Holstein, Jonathan. *The Pieced Quilt: An American Design Tradition.* Greenwich, Conn.: The New York Graphic Society, Ltd., 1973.

Hostetler, John A. "Amish Costume: Its European Origins."

The American-German Review (August–September 1956), pp. 11–14.

_____. "Amish Family Life. A Sociologist's Analysis." *Pennsylvania Folklife*, 12 (Fall 1961) pp. 28–39.

_____. *Amish Society*, rev. ed. Baltimore, Md.: The Johns Hopkins Press, 1968.

_____. "The Amish Use of Symbols and Their Function in Bounding the Community." *Journal of the Royal Anthropological Institute*, 94, no. 1 (1963), pp. 11–22.

_____. *Annotated Bibliography on the Amish.* Scottdale, Pa.: Mennonite Publishing House, 1951.

_____, and Huntington, Gertrude E. *Children in Amish Society.* New York: Holt, Rinehart and Winston, 1971.

Huntington, Gertrude E. "A Dove at the Window: A Study of an Old Order Amish Community in Ohio." Ph.D. dissertation, Yale University, 1957.

Jordan, Mildred. *Proud to Be Amish.* New York: Crown Publishers, Inc., 1968.

Kalm, Pehr. *Travels into North America.* 2 vols. London, 1772.

Klein, H. M. J., ed. *A History of Lancaster County, Pennsylvania.* Vol. 1. New York: Lewis Historical Publishing Co., 1924.

Kollmorgan, Walter. *Culture of a Contemporary Rural Community: The Old Order Amish of Lancaster County, Pennsylvania.* Rural Life Studies #4. United States Department of Agriculture, September 1942.

Kouwenhoven, John A. *Made in America.* Garden City, N.Y.: Doubleday & Co., Inc., 1949.

Landis, D. B. "Early Arts, Customs, and Experiences in Lancaster County." *Lancaster County Historical Society Proceedings*, 37 (1933).

Larkin, David, ed. *Innocent Art.* New York: Ballantine Books, 1974.

Lichten, Frances. *Folk Art Motifs of Pennsylvania.* New York: Hastings House Publishers, 1954.

_____. *Folk Art of Rural Pennsylvania.* New York: Charles Scribner's and Sons, 1946.

Lithgow, Marilyn. *Quiltmaking and Quiltmakers.* New York: Funk and Wagnalls, 1974.

Little, Francis. *Early American Textiles.* New York: The Century Co., 1931.

The Mennonite Encyclopedia. Scottdale, Pa.: The Mennonite Publishing House, 1955–1959.

Miller, E. Jane. "Origin, Development and Trends of the Dress of the Plain People of Lancaster County." Master's thesis, Cornell University, 1943.

Mombert, J. I. *An Authentic History of Lancaster County.* Lancaster, Pa., 1869.

Montgomery, Florence M. *Printed Textiles: English and American Cottons and Linens.* New York: The Viking Press, 1970.

Newswanger, Kiehl, and Newswanger, Christian. *Amishland.* New York: Hastings House Publishers, 1954.

"One Day in the Life of an Amish Woman." *The Independent*, 4 (July 1903).

Orlovsky, Patsy, and Orlovsky, Myron. *Quilts in America.* New York: McGraw-Hill Book Company, 1974.

"Pennsylvania Dutch Folk Art: A Selected Bibliography."
The Bulletin of the New York Public Library, 46 (June 1942), pp. 471–483.

Ramsey, L. G. G., ed. *The Complete Encyclopedia of Antiques.* New York: Hawthorn Books, Inc., 1962.

Rice, Charles, and Steinmetz, Rollin C. *The Amish Year.* New Brunswick, N. J.: Rutgers University Press, 1956.

Richardson, W. H. "A Day with the Pennsylvania Amish." *Outlook*, 61 (April 1, 1899).

Rosenberger, Homer Tope. *The Pennsylvania Germans, 1891–1965.* Lancaster, Pa.: The Pennsylvania German Society, 1966.

Rush, Benjamin. "An Account of the Manners of the German Inhabitants of Pennsylvania." In Rupp, I. D., ed., *An Original Fireside History of German and Swiss Immigrants in Pennsylvania from 1682–1765.* Privately published, 1875.

Schaefer, Herwin. *Nineteenth Century Modern.* New York: Praeger Publishers, 1970.

Schantz, F. J. F. *The Domestic Life and Characteristics of the Pennsylvania German Pioneer.* Lancaster, Pa.: The Pennsylvania German Society, 1900.

Schreiber, William. *Our Amish Neighbors.* Chicago: University of Chicago Press, 1962.

Smith, E. L. *The Amish People.* New York: Exposition Press, 1958.

Stevenson, W. Fletcher. *Pennsylvania Agriculture and Country Life, 1640–1840.* Harrisburg, Pa.: Pennsylvania Historical and Museum Commission, 1950.

Stewart, Susan. "Sociological Aspects of Quilting in Three Brethren Churches in Southeastern Pennsylvania. *Pennsylvania Folklife* (Spring 1974), pp. 15–29.

Stoudt, John Joseph. *Early Pennsylvania Arts and Crafts.* Cranbury, N. J.: A. S. Barnes, 1964.

_____. *Pennsylvania German Folk Art: An Interpretation.* Allentown, Pa.: Schlecter's, 1966.

_____. *Sunbonnets and Shoofly Pies: Pennsylvania Dutch Cultural History.* Cranbury, N. J.: A. S. Barnes, 1973.

Vincent, John Martin. *Costume and Conduct in the Laws of Basel, Bern, and Zurich, 1370–1800.* Baltimore, Md.: Johns Hopkins Press, 1935.

Warwick, Edward; Pitz, Henry C.; and Wycoff, Alexander. *Early American Dress, the Colonial and Revolutionary Periods.* Vol. 2. New York: Benjamin Bloom, 1965.

Wenger, John C. *History of the Mennonites of the Franconia Conference.* Souderton, Pa., 1937.

Weygandt, Cornelius, *The Red Hills: A Record of Good Days Outside and In.* Philadelphia: University of Pennsylvania Press, 1929.

Whitmore, Eleanor. "Origins of Pennsylvania Folk Art." The Magazine *Antiques*, 38 (September 1940), pp. 106–110.

Wick, Barthinius, *The Amish Mennonites.* The State Historical Society of Iowa, 1894.

Yoder, Don. "The Costumes of the Plain People." *The Pennsylvania Dutchman*, 4, no. 13 (March 1, 1953), pp. 6–7.

_____. "Plain Dutch and Gay Dutch: Two Worlds in the Dutch Country.' *The Pennsylvania Dutchman*, 8, no. 1 (Summer 1956), pp. 34–55.

_____. "Sectarian Costume Research in the United States." In *Forms Upon the Frontier*, edited by Austin E. Fife. Logan, Utah: Utah State University Press, 1969.